CELTIC ART

AN INTRODUCTION

Ian Finlay

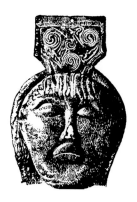

NOYES PRESS

Park Ridge, New Jersey

Published in the United States by:
Noyes Press
Noyes Building
Park Ridge, New Jersey 07656

Contents

Illustrations

MAP

Acknowledgments

The compiling of this book began many years before the writing of it, and I am indebted for help to a great number of people in this country and abroad, especially to my colleagues in museums. I am particularly grateful to Mr R. B. K. Stevenson, Keeper of the National Museum of Antiquities of Scotland, who read the typescript and made valuable suggestions; to Dr Isobel Henderson, who also read the typescript, with special reference to the Picts; to M. René Joffroy, Curator of the Musée des Antiquités Nationales at St. Germain-en-Laye, who gave me his criticisms of the chapter on the Gauls; and to M. Egloff of the Musée Cantonal d'Archéologie at Neuchâtel for his advice on makers' marks on La Tène swords. I would also include my publishers' specialist reader, whose comments were of great service. None of these, of course, is involved in responsibility for any conclusions which I may have drawn.

The study of many works of the earlier period was immeasurably facilitated by the exhibition of Early Celtic Art, directed by Professor Stuart Piggott, at the Royal Scottish Museum, Edinburgh, in 1970.

Acknowledgment of the sources of photographs is made below, but I would express warm thanks to owners for providing me with pictures or permitting me to photograph their material. Among several institutions which gave me facilities I would mention particularly the Hunterian Museum of the University of Glasgow, where Dr Anne Robertson, Keeper of the Hunter Coin Cabinet, devoted much time to helping me. I am specially grateful also to Mr R. C. M. Thomson, not only for his own photographs, which include the four colour plates, but for his untiring counsel over the photographs taken by myself.

Mr Giles de la Mare of Messrs. Faber & Faber has been ready with his advice at all times and has shown much forbearance with my delays.

<div align="right">I.F.</div>

Acknowledgments for Photographs

Avignon, Musée Calvet Plate 31
Bonn, Landesmuseum Plates 14, 15
Copenhagen, Nationalmuseet Plates 20, 21, 74
Stewart Cruden Plate 94
Douglas, The Manx Museum Plate 79

Dublin, Borde Failte Plates 81, 91, 92

Dublin, Commissioners of Public Works in Ireland, Plates 78, 80, 93, 99, 107

Dublin, The Green Studio Ltd. Plates 65, 86

Dublin, National Museum of Ireland Plates 48, 64, 70, 73, 77, 88, 100, 101, 102, 103, 104, 106, 108

Edinburgh, Royal Scottish Museum Plate 111 (by courtesy of Dame Flora Macleod of Macleod)

Glasgow, Hunterian Museum Plates 34(c), (d), (e), 57(a)–(h)

London, British Museum Plates 11, 49, 89

Nîmes, Musée Archéologique Plates 1, 29

Oxford, Ashmolean Museum Plate 6

Stuttgart, Landesmuseum Plates 7, 13, 16

R. C. M. Thomson Colour Plates I, II, III, IV (by courtesy of the Dean and Chapter, Lichfield Cathedral). Plates 10, 12, 17, 19, 23, 26, 27, 32, 35, 51, 53, 55, 56, 59, 60, 62, 67, 85 (by courtesy of the Dean and Chapter, Lichfield Cathedral), 96, 97, 98

Vienna, Naturhistorischesmuseum Photograph for Figure 9

(*Photographs taken by the author* Plates 2, 3, 4, 5, 8, 9, 18, 22, 24, 25, 28, 30, 33, 34(a), (b), (f), (g) and (h), 36, 37, 38, 39, 40, 41, 42, 43, 44, 45, 46, 47, 50, 52, 54, 58, 61, 63, 66, 68, 69, 70, 71, 72, 75, 76, 82, 83, 87, 89, 90, 95, 105, 109, 110)

Acknowledgments for Figures

Associated Book Publishers Ltd. Figures 46, 47

British Museum Trustees Figures 2, 8, 10, 11, 13, 16, 23, 28

Dr Egloff, Neuchâtel Figure 15

Dr Isobel Henderson and Thames & Hudson Figure 118

McCorquodale Printers Ltd., Manchester Figure 43

Royal Irish Academy and Thames & Hudson Figure 36

Zodiaque: La Revue Chrétienne des Arts, Paris Figures 32, 33, 34, 35, 42

Introduction

There have been many books on different aspects of Celtic art, and there is an extensive literature scattered through the learned journals. But most of those books and papers only make their full impact if one brings to them much preparatory reading. The standard work on the classic period, Paul Jacobsthal's *Early Celtic Art*—mine of information though it is—cannot be called an easy book, even for a specialist. The purpose of the present book is to draw together in one volume some of the ablest artistic achievements of the Celtic peoples from prehistoric times to the earlier centuries of the Christian era, and to comment on their significance. Occasionally this is like tightrope-walking. Authorities do not always agree on the issues involved, or even on the propriety of carrying the story beyond the overthrow of the main Celtic tribes by Rome. It is in fact impossible to be sure where Celtic art begins or ends, but the Celt's attitude to art appears so fundamentally opposed to the classical world's that it must to some extent survive wherever there are Celts.

Romantic art did not begin with the nineteenth century. It is one of the problems of trying to clarify the study of Celtic art for the general reader that the subject attracts the attention of large numbers of sentimentalists and finds itself linked with causes from Jacobitism to Art Nouveau. The Ossianic mists will never disperse. But Celtic art is Romantic with a capital R, a major element in that great stream of anti-classical art which has contributed so much to European culture, and which later produced the phenomenon of Gothic art and—later still—such artists of genius as Byron and Beethoven, Turner and Delacroix. Without this surging stream Europe might have been a barren desert fringing the ruins of Mediterranean civilisations. Even classical revivals were to be inspired by Romantic visionaries. The strange, precarious tensions and balances that support the web of Romantic art are clearly present in the art of the Celts.

Another difficulty encountered in establishing the importance of Celtic art in the European context is that so much of it is essentially abstract. Not only is classical art mainly representational; our education and upbringing are such that most of us have some aquaintance with what is being represented so that it is also more or less articulate for us. This and the long tradition of humanism in the western world have so influenced our critical faculties that we find it hard to recognise in Celtic abstractions achievements worthy to rank as anything more than decorative art. Yet they are so much more than this. The idea of purely decorative art may actually have been something beyond the compre-

hension of the ancient Celt. Before we can begin to evaluate the work of Celtic artists we have to perform a considerable feat of mental agility, forsaking our familiar humanist standpoint for something more precarious. We have to penetrate and take up our stance in that world beyond the pale of 'civilisation' which Greeks and Romans regarded as barbarian. It is more difficult than it might be because, unlike the oriental world, it has bequeathed us no literature to help us understand the barbarian mind. And at the same time it is a mind much less alien to us of the north than the oriental mind because the emotions and impulses that animated it are still alive in us, and can not seldom be touched off by those works of art that at first seem completely foreign and inscrutable. Here we may seem to be walking into the mists of that sentimental romanticism which I have warned against; but unless we accept the view that Celtic abstractions were devised merely to titillate and delight the senses, then we must make some attempt to elucidate their mysteries and estimate their significance. In doing this, we have to look into the even dimmer shadows that lie behind the Celtic world. The Celts inherited not only techniques but ideas from the Bronze Age.

There have also been many books about the Celt himself; some of them appear in the bibliography at the end of this volume. However much we read about him he remains a little shadowy. And yet he is not quite just another barbarian. Both Greeks and Romans feared him—as well they might—descending from his fastnesses to challenge first a decadent Aegean civilisation and much later the majesty of Rome herself. Writers ranging from Herodotus to Caesar give us a composite picture of him:[1] large of stature, powerful, courageous if reckless in war, delighting in show and colour, hospitable and generous and eloquent—did not some Romans engage Celts to tutor their sons in rhetoric?— though given to extremes and over-indulgence and any cause which moved him. Sculptured representations of him survive as well.[2] They are of course mainly classical interpretations, as for example the celebrated *Dying Gaul*, and exceptions like the stone warrior at Nîmes (Plate i), which is in a mutilated state, do not convey a great deal. Wherever found, such representations usually have common features such as neck-torcs and characteristic long shields. What the Celts were not, however, is a single, clearly-defined nation. They are elusive and baffling, appearing now as Gauls or Britons whom Caesar campaigned against, now as Celtiberians in Spain, now as those Galatians for whom Paul wrote his Epistle, now as the great tribe astride the trade-route from north to south that has given its name to modern Bohemia.

We know what the Celt looked like, we know something of what he achieved: what he thought about is another matter. Here we have to rely on our knowledge of him after he began to write things down, which happened in Ireland somewhere about the fifth century A.D.—by which time he was no longer a pagan. Our most profitable source of

[1] Caesar, *De Bello Gallico* VI; Strabo IV.
[2] cf. J. Déchelette, *Manuel d'Archéologie Préhistorique, Celtique et Gallo-Romaine*, Paris, 1914, pp. 1580–93.

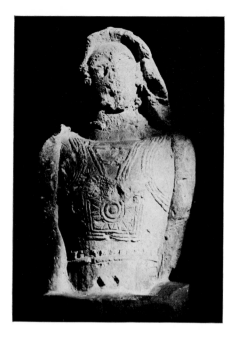

Plate 1
BUST OF GAULISH WARRIOR,
probably part of statue. France—
Grézan (Gard): 4th century B.C.
Height 72 cm. (head 19 cm.)
Nîmes, Musée Archéologique

evidence is the Welsh and Irish literatures of later times, filled with strange tales and legends that mirror the Celtic mind and character. Arthur may not have been quite the hero-figure of Malory, nor the Gothic knight-errant who does vigil with those other Black Men round the tomb of Maximilian at Innsbruck. The ancient basis of the legend, though, is not so much Arthur as the attitude of the society that exalted this sort of man; and it is significant that for the western society of later times Arthur has become the embodiment of a quixotic idealism constantly confronted by the humanism and rationalism that belong with the other half of our heritage. It is interesting to find that, on the evidence of the waggon-burials of South Germany or Burgundy, it is precisely this sort of warrior-hero, lauded by the bards, who emerges as the shadowy patron of the arts in early Celtic communities. But this is only one side of the coin. Boudicca and Cartimandua, and indeed probably the princess of Vix too, were no romantic heroines, any more than Caratacus or Vercingetorix had the manners and morals of respectable Victorian gentlemen. Even if there had been no Dio Cassius to tell us bluntly what a Celtic Amazon looked like, no Diodorus to describe Celtic head-hunting, we are confronted by the savagery of the *Tarasque de Noves* at Avignon and by the cult of skulls at Roquepertuse and Entremont. There we have the Celt of the oak groves, the Celt in his darker aspect, the frenzied Celt who exposed himself naked to his enemies in battle. Yet a consistent picture builds up. With the Christian era the Celt's mysticism took a different form and so did his courage, so that he still boldly exposed himself to his enemies, if with a crozier in one hand and a gospel-book in the other. He is the eternal rebel not only against established authority but against cold reason. As an Owen Glendower he may unite a nation behind him; equally he may be a mere Macdonell of Glengarry absurdly insisting on his

right to go 'with arms and tail' into the presence of his Hanoverian sovereign. He is a man who feels rather than calculates. Much as he may have admired it, and whatever his resources, he could not have built the Parthenon.

His apparent lack of tectonic ability and his seeming aversion to the human image are two failings which have prejudiced his position as artist in the sight of the western world. We are, I think now beginning to re-assess this position. Our canons of criticism have become more liberal, less firmly convinced of man's central role in the scheme of things. So far from being suspect, abstraction in art has become fashionable, even if its function is misunderstood. Though the Celt may have been unable to build a Parthenon, the works described in the chapters to follow are much more than samples of mere wayward decoration. They obey laws quite as demanding, quite as subtle, as those governing Greek architecture; their balances and tensions are infinitely delicate; their execution is not a matter of careless spontaneity, it is one of the utmost precision. Deviation from the accepted canons may have been as reprehensible in a Celtic artist as in a Greek. I have heard doubts expressed about the importance of the symbolism on the grounds that the 'symbols' have a direct aesthetic appeal and that this art needs no apology. Certainly it needs no apology. I am not prepared to believe, however, that this or the art of any ancient people is without a profound and deliberate significance, or that aesthetic appeal was more than a secondary matter with them. The Celt's 'aversion' to the human image will, it is hoped, become more understandable as the book progresses. His culture was based first on a pastoral and then on an agricultural way of life—its aristocratic manifestations being imposed by immigrant ideas—and the natural world with all its mysteries dominated his community, by contrast with the city-cultures of the Mediterranean world where man inevitably was central. The Celts were direct inheritors of Bronze-Age Europe with its Palaeolithic background. What they expressed in their art, and its means of expression, drew much from prehistoric tradition and although there are some masterly representations of man in very early times long before the Celts appeared, such things became so rare that one wonders whether they were not subject to some form of taboo. Avoidance of a human element does not make Celtic art 'primitive', only different. And where he escaped the strong influence of Rome, as in Ireland, the Celt clings to the ancient conventions which, it will be shown, continue to affect his outlook far into Christian times. In early Ireland and the countries influenced by her the symbol meant much more than the icon and dominated it. Indeed, the power of symbolism has never completely receded there, and many of us are still moved more by the high cross of Tuam, or even by the late and relatively crude Macmillan cross at Kilmory in Knapdale, than by an elaborate medieval altarpiece, however lovely. There is an uncanny power in a symbol that no amount of pictorial allusion can compete with, and if it is executed by a dedicated master it is worthy to be called a masterpiece in any company. In the same way the mystical significance of purely abstract forms may still be greater to a Celt than to anyone exposed only to the humanist tradition, and it may be said that a pattern page of the Book of Kells is as much an act of adoration as the singing of sacred music.

I

The Genesis of Celtic Art

It has been said in the Introduction that the Celt inherited much from the ages which came before him. Largely ignored in surveys of European art, as J. V. S. Megaw rightly stresses,[1] Celtic art is nevertheless a part of the very foundations of European art, a deeper and at the same time more broadly based element of it than has been recognised. The contribution of Mediterranean civilisation, so familiar and so easily understood, has obscured the importance of a culture that is in fact more basic for those of us who live north of a line drawn from the Pyrenees to the Carpathians.

A search for the beginnings of Celtic art must be made in the Late Bronze Age, possibly even earlier.[2] In the thirteenth and twelfth centuries B.C. great changes were taking place in Europe and in the adjoining territories. Empires such as that of the Hittites were being overturned and there were big movements of peoples. But the changes were pre-eminently technological, and consequently economic, so that the entire pattern of life in Europe north of the Alps began to alter. The Stone Age seems to have been left far behind. This is reflected in quantities of metal artifacts, some of remarkable sophistication. The new life can be deduced in particular, perhaps, from bronze utensils—often of considerable elegance—found over a vast area from central Europe to Scotland and Ireland, although it must be kept in mind that change reached the outlying areas much later. The highest levels of attainment seem to have occurred in the region which is now Hungary, producing elaborate ornaments of many kinds and a type of battle-axe with which this culture is especially associated. Weapons naturally had a special place. The sword had evolved into an efficient instrument of war, and the decoration bestowed on it, as on the axes, shows that it was looked upon as much more than a fighting tool: it was a symbol of prowess, maybe of authority. A class of master-craftsmen had evolved also, a class which was to have an honoured place, for among the Celts the complete hero was to be smith as well as fighting man, as Sandars says.[3]

Knowledge of metallurgy and of metal-working is one of the factors that promoted the rise of Celtic power. Bronze-Age Europe had efficient and beautiful swords which remind us of the shapely weapons of the Aegean civilisation, especially the Minoan culture of soon after 1500 B.C. The Aegean was invaded by peoples from the north about 1400 B.C. and again in the eleventh century. The northern invaders broke up the society

[1] *Art of the European Iron Age*, Bath, 1970, p. 7.
[2] V. Gordon Childe, *The Bronze Age*, Cambridge, 1930, p. 186.
[3] N. K. Sandars, *Prehistoric Art in Europe*, London, 1968, p. 165.

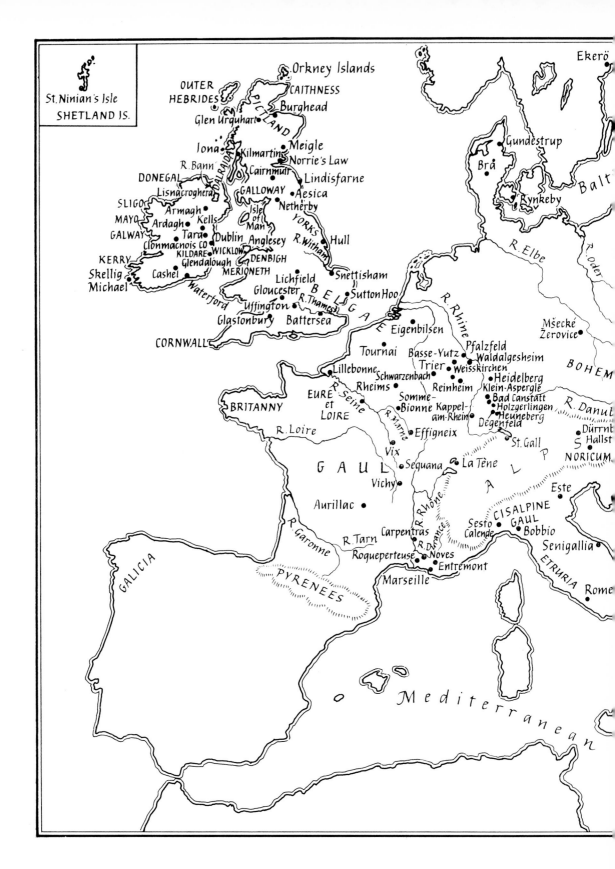

St. Ninian's Isle
SHETLAND IS.

Orkney Islands
OUTER HEBRIDES
CAITHNESS
Burghead
Glen Urquhart
PICTLAND
Iona
Kilmartin
Meigle
Norrie's Law
Cairnmuir
R. Bann
Lindisfarne
DONEGAL
Lisnacroghera
DALRIADA
GALLOWAY
Aesica
SLIGO
Armagh
Netherby
MAYO
Ardagh
Kells
Isle of Man
YORKS
GALWAY
Tara
Dublin
Anglesey
Hull
Clonmacnois CO
KILDARE WICKLOW
R. Witham
KERRY
Glendalough
DENBIGH
Skellig
Cashel
MERIONETH
Snettisham
Michael
Lichfield
BELGAE
Sutton Hoo
Gloucester
R. Thames
Waterford
Uffington
Eigenbilsen
Glastonbury
Battesea
CORNWALL
Tournai
Basse-Yutz
Pfalzfeld
Waldalgesheim
Trier
Weisskirchen
Lillebonne
Schwarzenbach
Heidelberg
BRITANNY
Rheims
Reinheim
Klein-Aspergle
EURE et LOIRE
R. Seine
Somme-Bionne
Bad Canstatt
Holzgerlingen
Kappel-am-Rhein
Heuneberg
R. Marne
Degenfeld
R. Loire
Effigneix
St. Gall
Vix
NORICUM
GAUL
Sequana
La Tène
Vichy
Este
Aurillac
CISALPINE
R. Garonne
Sesto
GAUL
R. Tarn
Carpentras
Calende
Bobbio
Roqueperteuse
R. Durance
Noves
Senigallia
GALICIA
PYRENEES
Entremont
ETRURIA
Marseille
Rome

R. Elbe
R. Oder
Ekerö
Gundestrup
Brå
Rynkeby
Baltic
Mšecké Žerovice
BOHEM
R. Danube
Dürrnberg
Hallst
ALPS

Mediterranean

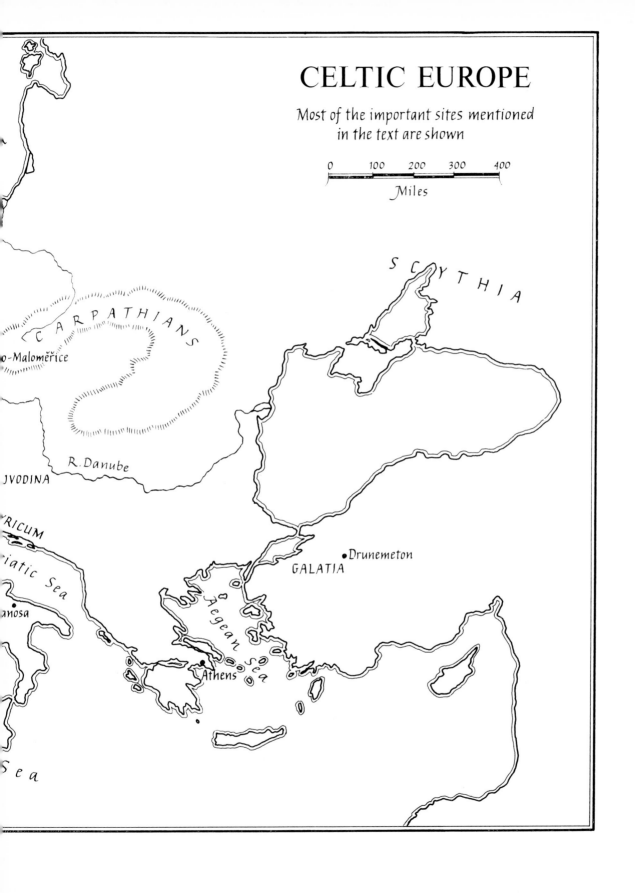

CELTIC EUROPE

Most of the important sites mentioned
in the text are shown

0 100 200 300 400
Miles

S C Y T H I A

C A R P A T H I A N S

o-Maloměřice

R. Danube

JVODINA

RICUM

iatic Sea

anosa

•Drunemeton

GALATIA

Aegean Sea

•Athens

Sea

of their victims but took back southern ideas with them. The northerners were skilled enough artificers in metal themselves, and had probably traded to the Aegean much of its copper anyway, but they acquired a new degree of elegance and sophistication in what they did. Central Europe had in fact resources of both copper and tin that gave it certain material advantages over the higher civilisations of the south-east,[1] so that it would scarcely be surprising if the north began to overtake the Mediterranean peoples in the capacity to make their growing strength effective. Technological skill was of course applied to agriculture as well as to war, and so the new society which arose in Europe became more stable. Its stability may have helped increase the hunger for conquest which had begun to stir; for populations must have increased steadily and the means to effect expansion must simultaneously have improved—as well as the need for it. The end of the Bronze Age left central Europe with great resources in the form of skills.[2] These were to carry the northerners forward into the Iron Age and make conquerors of their descendants. A heroic art developed, an art linked to the fighting man and his panoply which helped to determine the whole culture of Celtic society.

It is worth looking briefly at the art-forms that gradually came into being over the two millennia or so before Christ since they are basic to the style or styles known as Early Celtic that followed the Bronze Age. One characteristic feature of those art-forms is the Geometric decoration which occurs over a very wide area. This too may owe something to the Aegean. But Geometric ornament was produced in Europe over a span of thousands of years, probably indeed from the founding of farming communities between the seventh and fifth millennia onwards, when a ceramic art developed in Iran and Anatolia and spread into south-east Europe.[3] The term Geometric is self-explanatory. It indicates simple repeat patterns contrived largely from short straight lines and circles, producing such figures as chevrons, lozenges, triangles and circles with tangents. Patterns of this sort could be achieved with ease either by impression on soft clay before firing or by means of

Fig. 1
GREEK GEOMETRIC VASE
Schefold, *Meisterwerke*
Griechischer Kunst

[1] J. X. W. P. Corcoran, introduction to Norah Chadwick, *The Celts*, London, 1971, p. 25.
[2] Childe, ibid., Chapter II.
[3] T. G. E. Powell, *Prehistoric Art*, London, 1966, pp. 74–76.

24

paint. As Sandars remarks, they mark a stage in the history of ornament.[1] Effective as it may be—and it is much to our taste today—such decoration was crudely executed and was incised or impressed with anything from a piece of stick or a finger nail to a stamp. Pottery may have been regarded as expendable and not worth great care, but the metalwork associated with it is more sophisticated. The chevron appears on swords, daggers and spearheads, and on the double-axes from Hungary, as on Megalithic gold-

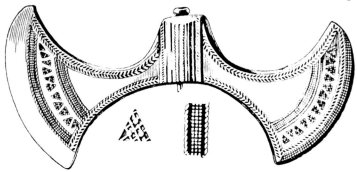

Fig. 2 DOUBLE-AXE, Hungary
British Museum Guide: Bronze Age

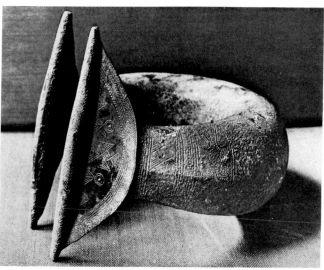

Plate 2 BRONZE ARMLET with Geometric decoration.
Hungary: Middle Bronze Age. Diameter c. 14.5cm.
Hitherto unpublished *Royal Scottish Museum, Edinburgh*

work from Ireland dating from around 2000 B.C. On metalwork the patterns are often delicate and subtle, even when the shape is bold as in the case of the bronze armlet from Hungary illustrated, which also exhibits a remarkable sense of plastic form, incidentally.

[1] Ibid., pp. 78–79.

25

The goldsmiths, too, instinctively exploit the qualities of the metal to obtain the maximum effect. The well-known lunulae, hammered into large areas of elegant outline, make use of gold's malleability, its mirror-brightness being emphasised with bands of Geometric decoration. Torcs express its ductability. Its gleam and sparkle are not only captured but symbolised in the little sun-discs found in Ireland, Wales and elsewhere. These discs are associated with horse-drawn cars on four wheels made for some ritual, possibly a blessing of the fields to promote fertility, a ritual that may in addition be reflected in the 'sun-flower' pins. Geometric decoration marks areas of the surface of the crescentic jet necklaces found in quantities in Scotland.

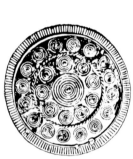

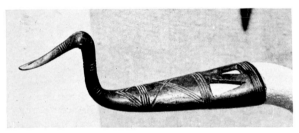

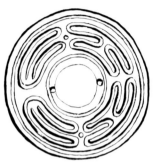

Fig. 3 SUN-DISC, Ireland
After Childe,
Bronze Age

Fig. 4 JET NECKLACE, Scotland
From photograph

Fig. 5 BRONZE SHIELD,
Auchmaleddie
From photograph

Quite early in the Bronze Age an organic quality begins to make itself felt in northern art, a sense of living design. This is basic to the anti-classical nature of Celtic art, which is therefore seen to have its roots deep in the age that went before. There was lavish use of the spiral, for example on armlets and even finger-rings; and in the bold reliefs on a bronze shield found at Auchmaleddie in Aberdeenshire there is promise of the plastic qualities that were later to be expressed so brilliantly. These motifs and patterns have a restless feeling foreign to the south—questing linear patterns regarded by Worringer

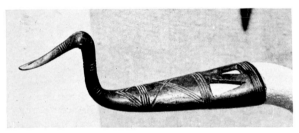

Plate 3 BRONZE TERMINAL in form of duck's
head. Hungary—Zsujta hoard:
1200–1000 B.C. Length 19.4cm.
*British Museum, London, by courtesy of
the Trustees*

26

as essential to the art of northern Europe.[1] Then again there are the natural forms. The arresting impressions of wild creatures done in Palaeolithic times now become gracefully stylised without losing spontaneity. One thinks particularly of birds, notably aquatic birds as on the duck-head terminal from the Zsutja hoard in the British Museum. The birds are an aspect of an ancient cult to be mentioned more fully in the next chapter.

It is impossible to say precisely when or where the historical Celts appear on the scene. They seem, however, to have emerged in central Europe during the millennium before the birth of Christ. One spot in particular has become a place of pilgrimage for archaeologists and others searching for evidence of their emergence. A few miles south of the town of Bad Ischl in Upper Austria, a fashionable spa in the reign of the Emperor Franz Josef, a gorge penetrates the mountains. At the head of it lies a deep blue lake shadowed by the massif of the Dachstein. Perched on the lake's edge is the village of Hallstatt with streets so steep that the annual procession of Corpus Christi has to take place by boat. From the village a cable railway carries one high above the forested lower slopes to a narrow, hanging meadow. A few unobtrusive notices among the trees indicate the bounds of a prehistoric grave-field. Two or three thousand of the graves have been investigated since they were discovered in 1846 and some of the finds are displayed in the little museum on the site, while more are to be seen in an old house down in Hallstatt, itself converted into a museum of local material. The bulk, including the finest, have been removed to the Naturhistorischesmuseum in Vienna and to other similar institutions. The finds are from different epochs and cover a considerable span of time. Among them were many objects wrought in a style unknown before, a style that marks what is now given the name of the Hallstatt culture. It has been dated to about 1000–500 B.C., although Sandars puts it a little earlier.

It is hard to imagine any community but the most primitive dwelling in this place at a time when Greece was still in the Homeric age. Yet many of the ornaments and weapons recovered from even the earlier graves are remarkably accomplished and display great technical ability. The latter graves contained cremation burials—the ashes being deposited in urns—that belong to a part of the Bronze Age known consequently as the Urnfield Period, and it is during this period that the art style which the Celts were to develop becomes discernible. Hallstatt also has a special interest in that it reveals very clearly the economic setting without which the Celts could not have risen to power and developed a culture of their own. The mountains were the frontier between north and south, the community lying close to one of the main ancient trade-routes. Traffic going south from the copper mines must have passed this way, and much of the amber supply from the submerged fossil conifer forests of the Baltic must have come by the same route to Hatria on the Adriatic, to be distributed all over the Mediterranean. Probably slaves were among the merchandise from the north, too. But the circumstance that contributed most to the prosperity of the communities of Upper Austria in those centuries was the presence of the salt mines that have given the district the name of the Salzkammergut,

[1] Wilhelm Worringer, *Form in Gothic*, London, 1927, new ed. 1957, chapter VIII.

and the hillside above the grave-field at Hallstatt is riddled with galleries that are still worked. Salt was a vital commodity in the ancient world: important as a preservative, it was also used as money; it had an important part to play in sacred offerings; it was a symbol of binding covenants; and it was believed by many to be of divine origin. The rock-salt of Austria was in vast supply, and the bargaining power of those transalpine communities can be more readily understood after a visit to any of the great mines of the Hallstatt district, or even to the exhibit in the Deutchesmuseum in Munich. In return the communities received the products of the Mediterranean world. From about the seventh century B.C., they included various luxury goods, especially wine contained in figured vessels such as amphorae, which must in themselves have stimulated the curiosity of the northerners. It is hardly possible to exaggerate the importance of the wine-trade in promoting the art of the north at this formative stage. On the other hand, one can come to misleading conclusions about its effects. Friedrich Morton, in his little book,[1] describes the 'Hallstattzeit' as culminating in luxury and decline that made it an easy victim for great incoming waves of Celts, the 'Keltenwanderungen', around 400 B.C. He may or may not have been persuaded of this by the wine imports, but it is doubtful if they had any demoralising effect on a society which seems rather to have been growing in strength and aggressiveness; and indeed the old theory that all Celts were incomers dominating native populations is untenable, for the Celtic rise to power was manifestly broad-based and is hardly explicable even in terms of migrations. Dr Jiri Neustupny remarked recently[2] that 'migrations in prehistoric Europe were extremely rare, if any', adding that the investigation of domestic development of cultures seemed a more profitable approach; and Megaw suggests that the 'migrations' were swift-moving raiding-parties.[3]

The horse-furniture which Megaw sees as evidence of raiding-parties brings us to an important aspect of certain Hallstatt burials typical of the whole region that are associated with the emergence of the Celts. This is a type of inhumation which has come to be thought of as the princely tomb. The corpse, this time uncremated, lies in a waggon or carriage and is provided with weapons, utensils, sometimes trappings for horses, and even food, all of which clearly imply belief in a life after death. The man's sword is no longer of bronze but of iron. In some cases the burial is under an earthen mound, a barrow, covering a wooden chamber. In the earlier tombs, equipment is not really very princely, though it does point to a special caste—to some sort of chieftain. The inference must be that a change had come about in society, because sepulchral evidence suggests that the previous Urnfield society was more egalitarian. Leaders were arising. They were taking over in a time of technological advance and they would consolidate their power by means of better tools for working the land as well as better weapons. And, as always, a new aristocracy had a use for the artist and craftsman to help emphasise its superior status. What we have here is not the arrival of a new master-race so much as the discovery of

[1] *Hallstatt und die Hallstattzeit*, Hallstatt, 1955, pp. 92–93.
[2] *Illustrated London News*, 18.3.1967, p. 24.
[3] Megaw, ibid., p. 13.

their potentialities by a chain of gifted communities that are linked by, among other things, an Indo-European speech which we know as Celtic.

By the beginning of the fifth century B.C. the province of these people or peoples is enormous. It covers not only Austria and Bohemia but the whole of the Rhineland, all of France except the north-west, and the northern half of Spain and Portugal. It also includes an area south of the Alps, as well as south-east England. To-day, at a time when this region is broken up into a number of widely-differing nations, it is hard to comprehend that in the centuries just before Christ it was virtually united in outlook and in culture. It cannot be said there was anything like political unity. It was a tribal society, and although that may imply common loyalties, it implies dissensions and wars as well. The basis of the common outlook and culture may in part be a question of racial origins, though perhaps it owed most to that long-enduring Bronze-Age society. Intercourse between widely-separated parts of the region was almost certainly less difficult than an impression of endless impenetrable forests and impassable swamps seems to allow, because of the trade-routes. The peoples were of predominantly Aryan stock, and their surviving place-names show that they spoke closely-related languages and seem to have done so since 2000 B.C.[1] The region represented the greater part of the northern world, divided from the Mediterranean world not so much by intervening mountain barriers as by orientation, for the Mediterranean peoples looked inwards towards one another, turning their backs upon the barbarians of the north. The antithesis between the two worlds is fundamental. This the arts were bound to reflect. The southern approach is a clear-cut, rational one, allowing aesthetics to be reduced to formulae and all hopes and fears to a human scale. The very gods were no more than immortal supermen with human appetites and weaknesses writ large; their statues and their temples were monuments to humanism. By contrast, Jacobsthal calls Early Celtic art 'dark and uncanny—far from the lovable humanity and transparence of Greek art'.[2] The background to the northern artist's thoughts was the lore from a primeval past and a present environment of forest and swamp. There was, however, a great store of wisdom as well as of superstition in his inheritance, a wisdom drawn from constant close contact with natural forces acting—and it is a fact that is sometimes forgotten—upon a race of high intelligence and potential. It was not a mere confrontation of civilisation and barbarism, as I have already stated in the Introduction. As Josef Strzygowski has put it, the problem has to be looked at 'with our own, that is, with northern eyes'.[3] The Celts have been called perhaps the most important cultural group in central and western Europe. Their art is a crystallisation of the arts of pre-historic Europe that was brought about in part through the catalytic action of Mediterranean and oriental influences. The graves of the Hallstatt warrior-chieftains disclose the beginnings of their Homeric age.

[1] Myles Dillon and Norah Chadwick, *The Celtic Realms*, London, 1967, p. 214.
[2] Paul Jacobsthal, *Early Celtic Art*, London, 1970 (new ed.), p. 163.
[3] *Early Church Art in Northern Europe*, London, 1928, p. 2.

II

The Hallstatt Culture

The opening up of the Hallstatt grave-field showed that the communities north of the Alps had entered the Iron Age and had undergone a change in their social patterns. This could not have happened suddenly because subsequent evidence from other parts of Europe, the British islands included, has shown that the Hallstatt culture was very widely distributed indeed. It is possible, even probable, that the Hallstatt region was at first pre-eminent, partly because it lay well southward on the trade-route and must have felt the impact of new ideas early, and partly because it possessed large ore deposits of high quality. Noreia, forty miles from Hallstatt, grew into one of the great iron-working centres; the province in which it lay, Noricum, became powerful both economically and militarily. But it is important to stress that there was no Hallstatt 'black-country', and that, with the wide distribution of iron deposits, tribes all across Europe could develop their own skills and prosperity—which would stir in them their appetite for war.

The coming of the Iron Age does not mean that iron replaced bronze, especially as a medium for the arts. At the period of those first iron swords, around 800 to 700 B.C., iron was primarily a useful material and probably attracted the artist little. There must have been a lengthy transitional period, or overlap, and the earliest worked iron may have been no tougher than bronze and no improvement upon it. However, there is no doubt it was cheaper to produce, and in the long run it was to revolutionise agriculture much as it had revolutionised war. Only the blades of the early swords were of iron: craftsmen in central and western Europe had built up great expertise in working bronze and precious metals, and as bronze could be not only cast but hammered thin—and was in fact a marvellously plastic medium—it offered artistic opportunities not available in iron. Hilts and scabbards and everything else that did not have to withstand violent impact or abrasion continued to be of bronze far into the Iron Age.

If heavy emphasis has been placed on the basically northern character of the new art forms, Hallstatt did reveal evidence of influences from other directions as well. At the end of the last chapter a passing reference was made to oriental influence. This is reflected in the earlier chieftains' graves at Hallstatt. Not only do the accoutrements and weapons betray contacts with the Near East, but the idea of ceremonial inhumation itself seems to come from this source, while the obvious growing importance of the horse—chieftains were laid in four-wheeled waggons, and sometimes the bones of horses were present—

30

seems to point toward the steppe-lands of south Russia and to nomads such as Scyths and Cimmerians, for whom the horse was an essential part in the pattern of life. Bronze bits and bridles, the funerary car itself, are prestige indications, setting these dead apart from lesser men who were not horse owners. It is tempting to see in the association of the horse with a ruling class an early pointer to what ultimately became the concept of chivalry. On the practical side, contact with easterners must have demonstrated to the Europeans how mastery of the horse lent power over horseless neighbours. Among the Scyths horses were not merely for the privileged, as horse-breeding and maintenance on the steppes were not difficult. In the forested valleys of central Europe matters were different. Horses must have been limited in numbers and therefore mainly the perquisites of chieftains, which explains the important part played by horse-furniture in the earlier period of

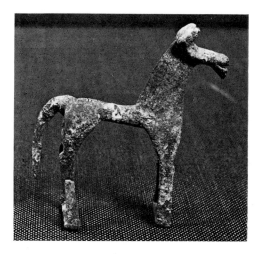

Plate 4
BRONZE HORSE. Macedonia—
Lake Doiran: about 7th century B.C.
Height 5.7cm. Hitherto un-
published
Royal Scottish Museum, Edinburgh

Celtic art. The horse was in a way a symbol of the rise and expansion of the Celts. The other influence apparent at Hallstatt was of course that of the south, evident throughout Hallstatt-culture sites. Greek wine-vessels were clearly much prized, though Etruscan material also found its way north and Etruscan bronze flagons and fine gold-work provided a strong stimulus for the northern metalworkers. Some of the oriental influence was probably filtered through the communities south of the Alps, too.

It was an era in which internal rivalries and pressures for expansion were building up, and undoubtedly the means and mood of conquest were present. It is appropriate therefore that weapons should be the objects on which artists chiefly lavished their skills. The sword could be taken as the symbol of the times. The blades of the earlier Hallstatt swords were relatively long, perhaps three feet or more, of considerable weight and essentially slashing weapons. The weight made necessary the counterpoise of a massive hilt. Much of this counter-weight is thrown into the pommel, which takes the form of a high-crowned hat, and it is on the hilt that decoration is concentrated. Commonly this decora-

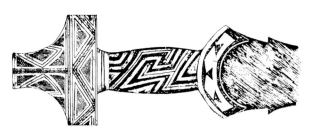

Fig. 6 HALLSTATT SWORD
Morton, *Hallstatt und die Hallstattzeit*

tion is of the Geometric type already discussed, or the surface may be covered with gold foil; or again, other materials may be used in the form of inlays, as in the case of the Hallstatt sword in the British Museum which has insets of ivory from Africa and amber from the Baltic, symbolising a meeting-point on the trade-route. Warriors seem to have found the long swords unwieldy, however, for a shorter-bladed weapon presently replaced them. The hilt now becomes a rather clumsy affair with a haunched pommel; this is obviously a forerunner of the 'anthropoid' sword which appears later. There are squat daggers with similar pommel, but there is a much handsomer type with pommel of twin knobs of which there is an example from the Hallstatt grave-field at Mainz; and there is an elegant little dagger with neatly-contrived, triple-branched pommel of which two examples at least are in the Hallstatt museum.

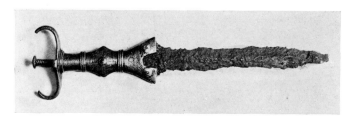

Plate 5 DAGGER with bronze hilt. Macedonia—Chauchitsa,
near Lake Doiran: about 7th century B.C.
Length 30.4 cm. Hitherto unpublished
Royal Scottish Museum, Edinburgh

The Hallstatt style has been called 'lifeless and sterile' compared with what went before, or with the La Tène style that followed. There is some justification for this description. Maybe the mistake is to call it a style at all, because during this period the elements which were to fuse into Early Celtic art were coming together and the basis for future developments was being laid down. And it is fair to say that when the swords and other artifacts were in their original state they must have been far from being lifeless or sterile. They may even have been impressive in a somewhat ponderous way, sparkling with glints of gold and pricked out with bright points of colour through use of coral, ivory and amber. The Geometric ornament is certainly a mechanical way of filling in a given space, and there is much repetitiousness in the use of punches applied to shields, to armour

32

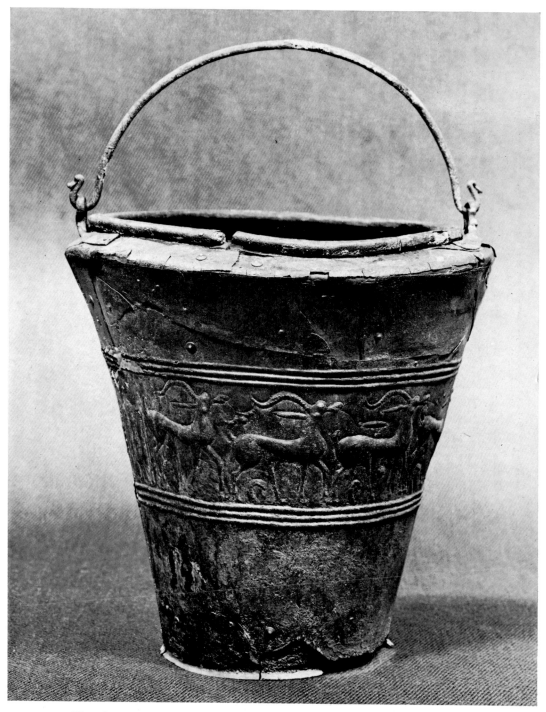

Plate 6 BRONZE SITULA. Yugoslavia—Vace, Carniola: 600–500 B.C.
Diameter 24.8cm.
Ashmolean Museum, Oxford

such as the cuirass in Geneva, or to various domestic vessels—a treatment which one writer has stigmatised, perhaps unfairly, as 'wholesale art' cheap to reproduce.[1] It is true that the zigzags, concentric circles and dotted patterns carried over from the Bronze Age are unoriginal and pedestrian; but there can be vitality and even significance in a repeat pattern, although the vitality may be sapped by dilapidation and wear. We who live in an age when repeat patterns have been emptied of meaning and have become clichés, fail to understand this when assessing the arts of peoples who never used decoration care-lessly. Far from lifeless is the so-called *situla* style, named from the bronze pails (*situlae*) embellished with horizontal bands of figures or animals done in *repoussé*, a menagerie of Near-Eastern origin. The animals are a little crudely outlined: horses, birds or whatever it may be, have a certain childlike artlessness. Yet the very beat of their recurrence suggests a primitive musical rhythm with overtones of some mystical rite, possibly a propitiatory one.

A brief digression on those ritual creatures is called for, because they run through the whole Celtic story. Dr Anne Ross has commented at length on the subject,[2] for the Celtic artist and his patrons were absorbed by the lore of animals and birds from the passing of the Bronze Age right down to Christian times. Thus the horse had powerful ritualistic associations and is invoked in all shapes and sizes throughout the lands where the Celts were to hold dominion from Sesto Calende to the chalk hill of Uffington in Berkshire where the outline of a spirited animal has been carved. The birds on a pail from Sesto Calende are drawn from a sizeable ornithological repertory. The swan imagery which was to play such an important part in Irish literature is anticipated in bronze even before the Hallstatt era. In Ireland itself there can be no mistaking the swan shapes among the birds on the curious sixth- to fifth-century B.C. shaft-mounting from County Antrim, now in the British Museum, a type that occurs too in central Europe. The romantic legends of swan-maidens and of the pursuit of the birds at the begetting of Cuchulainn are hinted at by the chains or chain-rings attached to the beaks of the birds of the shaft-mounts, so that

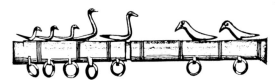

Fig. 7 SHAFT-MOUNT, Antrim
From photograph

they are legends of very ancient origin indeed. Dr Ross claims that the evidence suggests this swan-cult had a connection with the cult of the sun associated with the sun-discs and other relics of the Bronze Age.[3] One must always keep an eye on the literature of later times when looking at the early art.

[1] Dillon and Chadwick, ibid., p. 289.
[2] *Pagan Celtic Britain*, London, 1967, chapter VII.
[3] Ibid., pp. 236–7.

On the lid of a sixth-century pail from Hallstatt in the British Museum there is a procession of much more sophisticated animals: a goat, a stag, a lion and a sphinx. While the pail itself is a typical enough example of the riveted utensils of the time, the animals exemplify the Greek and ultimately oriental influence referred to earlier, to which I must return. The animals are in fact nearly direct transfers from Ionian pottery. In looking at

Fig. 8
LID OF PAIL,
Hallstatt
British Museum
Guide: Iron Age

proto-Celtic art this pail or *situla* is important because it embodies the penetration of transalpine Europe by those exotic ideas, some of which came by way of the Balkans, but whose chief threshold was the head of the Adriatic. Greek art had undergone what is known as an orientalising process. It is, I feel, rather a clumsy word or at least an inadequate one, in that it could be taken to mean a passing fashion akin to the *chinoiserie* craze that spread through Europe in the seventeenth and eighteenth centuries. The impact of the East on Iron-Age Europe was a much more profound event, even if it hardly merits Jacobsthal's description as 'one of the decisive deeds in the History of Man'.[1] By opening the door upon another world for a people who for hundreds of years had been using limited images and patterns, this Eastern influence helped release them from their Bronze-Age conservatism. Not that it penetrated far during the Hallstatt era. The pail and other things of the kind were executed in the Veneto-Illyrian *situla* style, and the artists were probably brought north over the mountains by the new chieftains. Another even more interesting piece, which Jacobsthal believes to have been made by an incomer from the Adriatic area to Hallstatt, is a sword now in Vienna. Engraved on the bronze scabbard in hair-fine outline are warriors, mounted and on foot, and men turning a wheel. Such narrative art is wholly foreign to the northern spirit, if it delighted the

[1] Jacobsthal, ibid., p. 161.

35

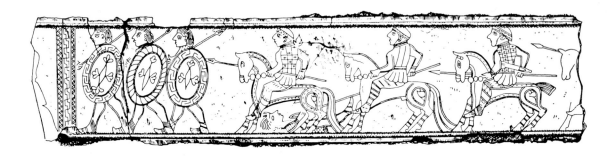

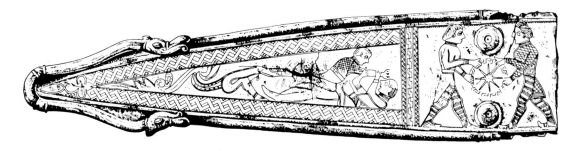

Fig. 9 HALLSTATT SWORD, Vienna
Photograph of drawing, Naturhistorischesmuseum, Vienna

artist's 'Gaulish masters', as Jacobsthal suggests.[1] It seems to have wakened no response among Hallstatt craftsmen. They were, after all, familiar enough with Greek vases and bronzes and the allegories depicted on them, but apparently rejected the 'every picture tells a story' approach. Instead they opted for Jacobsthal's 'weird magical symbols of the East'. Yet already the north may have had some effect on the foreigner, for the general lines are transalpine, while the double-dragon form of the chape, the scrolling floral 'tail' to the bending man and the haunch-whorls of the horses all indicate things to come.

Some gold-work of great beauty belongs to the Hallstatt period, and here southern influence is fused with northern feeling. It is executed with much taste. The sophistica-

[1] Ibid., p. 1.

36

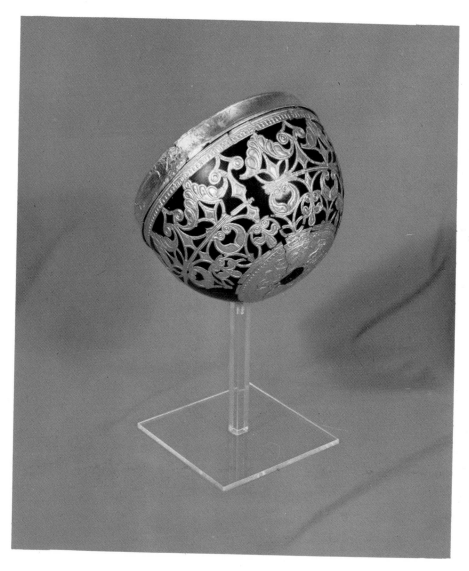

Plate I GOLD OPENWORK MOUNT for a cup. Germany—Schwarzenbach,
Birkenfeld: late 5th century B.C. Diameter 12·6cm.
Staatliche Museen, Berlin

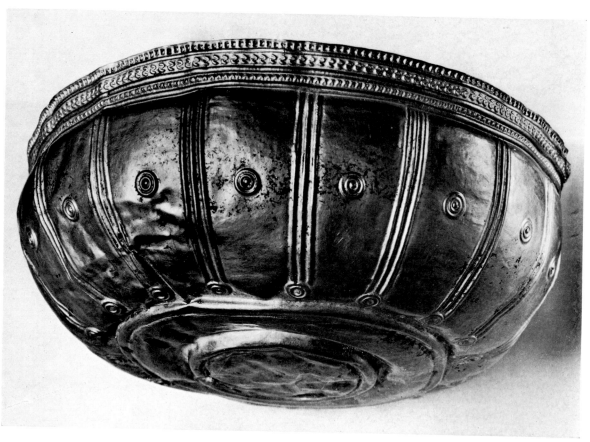

Plate 7 GOLD CUP. Germany—Bad Canstatt: late 6th century B.C.
Height 7cm.
Landesmuseum, Stuttgart

tion and delicacy of such pieces raises speculation about the background against which they were made, a matter which I will go into presently. A waggon-grave at Bad Canstatt near Stuttgart produced among other things a gold cup, its decorative elements deriving from Bronze-Age motifs being introduced with discrimination. Such a cup could have had a place in any rich household of the ancient world, although it had been placed in the grave as part of the funerary rite. This and an object of embossed sheet gold from the same grave date from late in the sixth century B.C. Still more beautiful is the openwork casing or mount for a cup, possibly made of clay, found in a grave at Schwarzenbach and now in the Staatliche Museen in Berlin. This has been dated to the later fifth century. As Jacobsthal states, it is in the Hallstatt tradition of the Canstatt find. Here classical inspiration is at once recognisable in the palmette motifs and honeysuckles—and indeed the contents of the grave included an Etruscan amphora—but the swirling quality of La Tène art is beginning to be anticipated, notably on the engraved foot. It must have been

a splendid object if Jacobsthal was right in surmising that the clay cup was coloured to imitate inlay. Gold was also used skilfully in the period for the decoration of weapons, as for example on the knobbed dagger from Hallstatt preserved at Mainz. Jewellery, on the other hand, is somewhat crude. Some brooches probably derive from Mycenaean prototypes, while others may themselves be prototypes of later forms. Spirals and sun discs are among the motifs. Earlier types include a curious crescent brooch with chain pendants, safety-pin fastening and confronted animal or bird motifs, represented in Vienna and in the British Museum.

Fig. 10 BRONZE PENDENT
BROOCH
*British Museum Guide:
Iron Age*

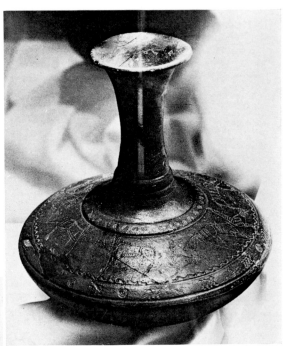

Plate 9
POTTERY FLASK. Germany—Matzhausen,
Oberpfalz: early 4th century B.C. Height 24.5 cm.
Museum für Vor- und Frühgeschichte, Berlin

Plate 8
EARTHENWARE PLATTER. Germany—Württemberg, Alb-Salem: 700–600 B.C. Diameter 38 cm.
British Museum, London, by courtesy of the Trustees

Some of the Hallstatt pottery is singularly effective. It is so much to our present-day taste that we may tend to over-praise what at the time were most likely regarded as quite pedestrian wares beside the Greek pottery so familiar to richer families in the Hallstatt

communities. The native wares are bold in pattern and sometimes extremely gay, like for example the Alb-Salem platters in the British Museum. Technically they are considerable achievements, the urns often being very large and the platters sometimes more than twenty inches in diameter—even larger in the case of a splendid dish at Mainz. The pottery is reddish, and contrasts are obtained by blackening areas with graphite. In many instances the patterns are Geometric, consisting of concentric circles, lozenges, chevrons and hatching, bold and attractively emphasised by the red and black colouration. Another type of decoration, equally bold and perhaps as effective, is the vertical and horizontal grooving that occurs on the great urn from Degenfeld (Württemberg) in the British Mu-

Fig. 11
URN FROM DEGENFELD
British Museum Guide:
Iron Age

seum. This belongs very early in the Hallstatt period, and of course all the ceramic patterns derive from the Bronze Age. The wheel had not yet been adopted in the north, which is perhaps surprising.

Reference was made earlier to the problem of the background or environment for which the more sophisticated objects, particularly the gold-work, were made. It is the view of most scholars that Celtic domestic arrangements were relatively primitive,[1] and the diorama in the Hallstatt museum reflects the general belief. It is based on a considerable body of evidence, both archaeological and documentary. The archaeological evidence for what may have been fairly simple dwellings shows that they were rectangular in plan in the Hallstatt era, though in western Europe the typical house was to be circular—indeed seems to have been so from the earliest times. Construction was of timber and thatch. There were more elaborate hill-forts, and they could be solidly built of mud-brick and stone combined with timber-work, as at Heuneberg. For the interiors and details of the dwellings the evidence is inevitably scanty. One classical writer certainly paints a rather crude picture of the sleeping quarters, which consisted merely of skins thrown on the floor, and we must assume that in the circular houses at least the fire must have been central, with a hole in the roof being made for the chimney. It does not leave room for much elegance. We know, too, both from classical authors and from Irish annals that the Celts drank heavily and were violent in their cups, and ate great quantities of meat, which must have been roasted on spits or boiled in cauldrons over the central fire. Both cauldrons and iron suspension chains have survived. All this might suggest they were indifferent

[1] cf. Anne Ross, *The Pagan Celts*, London, 1970, p. 88.

to their surroundings; but the classical writers admit to their cleanly eating habits and their fastidiousness and scorn of being gross in person. It must be accepted that the ordinary tribal houses were simple in construction. I find it hard, however, to accept that prideful, ostentatious chieftains, feasting and drinking Greek and Etruscan wines from fine vessels to the sound of bardic music, did so in a room no better than a cow-byre. We may be nearer the truth with Megaw's 'wooden halls worthy of a medieval baron' envisaged as part of the fortified hill-top settlements.[1]

The caveat about domestic conditions must not obscure the importance of eating and drinking habits for this formative stage of Celtic art. Food and drink did play a major part in the conduct of tribal life. The quantities of wine imported were enormous—fifty waggon-loads in a single consignment are recorded—and the artistic impact of the imports of figured *amphorae* and *oinochoai* has already been mentioned. Food also was bound up with the warrior-hero behaviour pattern that did so much to shape the cultures of the Hallstatt era and the era that followed. The hero's portion was a privilege jealously sought after and could occasion a quarrel to the death. The feast was an occasion for boasting and for extravagant praise or reproach, and it was as important for the artist to out-do other artists in the embellishment of his chieftain's festive vessels as his paraphernalia of war.

Writers on Celtic art have remarked upon the 'suddenness' of the appearance of the mature La Tène style, which will be described in the next three chapters. Jacobsthal claims that the new style flashes up 'with no genesis'.[2] Sudden as it may seem, I think there cannot be much doubt that most of the elements of the impending style are present in the Hallstatt culture—and some of them in the Urnfield culture which went before. What we have to look for in the first place is the strong northern root-stock on to which everything else was to be grafted, and from which the vigour of the new style sprang. Basic to this is the northern preoccupation with metal forms. The La Tène style could never have sprung from a tradition of stone-working—classical metalwork so often looks like a translation from a stone original—nor could it have been the creation of a people accustomed to expressing itself in wood or bone or ivory like the Africans or the Polynesians. Its fluidity and elusiveness are born of the properties of metals that can be melted and cast, or beaten thin, drawn out into tenuous shapes or surface-traced with the most intricate patterns. The exploitation of those properties down to Hallstatt times is still tentative, still experimental, but delight in the medium is everywhere and growing. It is no great or surprising step forward to the swirling forms of early La Tène. La Tène motifs are already taking shape in the curling pattern on the base of the Schwarzenbach bowl and, yet earlier, in the beautiful tracer-drawn designs on Bronze-Age metalwork in Scandinavia, such as razors and 'belt-boxes'. In so far as it has an iconography, Early Celtic art again diverges completely from the Mediterranean path, preferring the aquatic birds of northern tradition or the exotic creatures that came out of the east. As to repre-

[1] Megaw, ibid., p. 15.
[2] Jacobsthal, ibid., p. 157.

40

Plate 10 OPENWORK GOLD MOUNTING. Belgium—Eigenbilsen, Tongres:
about 400 B.C. Length 22cm
Musées Royaux d'Art et d'Histoire, Brussels

sentations of man, for all the examples he knew from figured pottery, the Celtic artist
rejected such imagery out of hand and reduced his own species to a formula as on the
linch-pin in Leiden or the axe in Vienna, a formula taken over almost in its totality by the
La Tène swordsmiths for their pommels. Only south of the Alps, among the Illyrian
bronze-smiths around Este from late in the seventh century, can one find in art within
the Celtic sphere of influence human beings as distinct from anthropoid images. That other
great characteristic of anti-classical art, the cult of asymmetry, does appear to be a later
development. Even the lobes and swirls of the Schwarzenbach bowl, or the Eigenbilsen
openwork band in Brussels, are symmetrical in composition. The subtleties and tensions
of asymmetry were refinements to be explored and expressed after the contributory ele-
ments of the new style had first been synthesised. This took place over a considerable
period, and our classifications of 'Hallstatt' and 'La Tène' are in some degree matters of
convenience, for the transition was not only prolonged in time but varied in pace in
different parts of an area comprising more than half of Europe.

41

III

The Heroic Age (1)
Early Celtic Art

The name 'La Tène' has become synonymous with the finest achievements of the style known as Early Celtic art. Its origin is the site at La Tène (the Shallows) close to the eastern end of the Lake of Neuchâtel, where an important hoard of objects was excavated, a hoard well represented in the Musée Cantonal d'Archéologie, Neuchâtel. The style, however, seems to have originated rather further north, in the Rhineland, around 500 B.C. It was to spread with infinite variations over great areas of France, and eventually Britain. To deal tidily with this widespread style is difficult, because developments in Gaul and Britain demand chapters to themselves, yet though the same designs and techniques appear throughout Celtic Europe, necessitating a certain overlap, it is the Rhineland region that determined the new forms.

It would be difficult to pick a typical example of the earlier developments of the style. In this period as in later times it is in metalwork that the Celtic artist attained the peak of his achievements, and it is doubtful if he did anything finer than the pair of bronze flagons from Nieder-Jutz (Basse-Yutz) on the Moselle, now in the British Museum. They are among the most beautiful objects of decorative art which have come down to us from antiquity; yet they are transitional pieces, in which several sources of the style are apparent, and one cannot say they have the maturity and assurance which one looks for in a truly splendid work. Superficially some of their beauty is fortuitous, as their rich colour is a matter of patina; but this gain only offsets the loss of the original brilliant colours, for the coral inlays have bleached to a dirty white and become roughened, and the enamels on the handles likewise have lost colour and, as Jacobsthal notes, would regain their deep red only if wetted.[1] The shape is elegant. The restraint with which the artist limited his colour and intricate ornament to handle, spout, lid and foot, shows faultless taste not only in himself but in his patrons, and contradicts the assertion sometimes made that the Celt did not understand the value of contrasting decorated with plain surfaces. The flagons came, no doubt, from a grave: they were dug up by workmen who carried off and hid them. As the Museum authorities suggest, they seem to have formed part of the table furniture of a chieftain, and, if that is correct, the feasts of a

[1] Jacobsthal, ibid., p. 200.

42

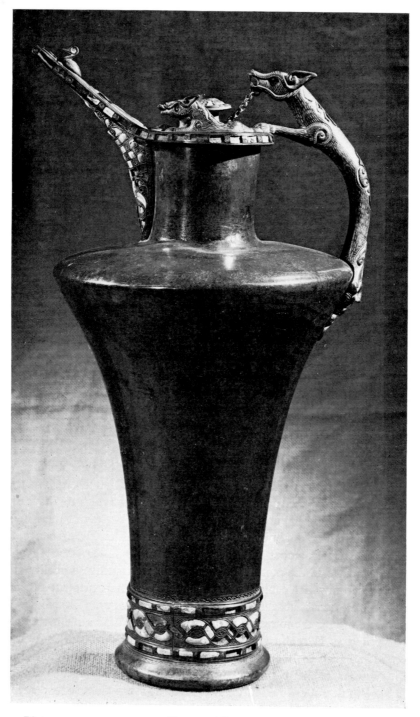

Plate 11 BRONZE FLAGON. France—Nieder-Jutz, Lorraine: early 4th
century B.C. Height 38.7cm.
British Museum, London, by courtesy of the Trustees

Celtic chieftain were indeed refined in their appointments however boisterous they may have grown in conduct as night wore on.

The use of coral and enamel is characteristic of Early Celtic art. Colour was an important element in Celtic design, although one must be cautious not so to stress this as to imply that other ancient peoples did not share such delight in colour. The most prominent detail of the flagons is the animal handles. These retain traces of naturalism in the treatment of fore-paws and fur, and in the alert postures, and there are present the conventional 'joint-spirals' which were to be typical of the Celtic animal. In this case the animal, a wolf perhaps or a dog, has evident Scythian antecedents and points to an association between Celtic peoples and the nomadic tribes of the Caucasus and Zagros regions and that 'horse-culture' which had been felt in transalpine Europe over many centuries; although it should be emphasised here that Persia is thought to have had a much greater part in the oriental influence than the Scyths.[1] Near the tip of the spout, comically unaware of the ravening beasts on its tail, is a small swimming duck. Though also stylised and fitted with out-sized coral eyes, the duck again reveals sensitive perception of natural forms. The flagons belong to the early fourth century B.C., being produced within about a century in fact of the appearance of the new style. Their immaculate taste is certainly one feature of the new style. Gone is the brooding heaviness of Hallstatt art. Evidently both artist and patron were persons of some sophistication. There is of course an unmistakable familiarity with the classical world, if the accent is Etruscan, which is underlined by a pair of imported *stamnoi* found with the flagons and exhibited with them, and one may guess that the wine served in the flagons was no raw local product but also imported. The importing of Greek wines was a major influence in the creation of the new style. The areas which have brought to light some of the finest early examples of the style, the Middle Rhine and upper Danube, have also produced in the waggon-graves fine quality drinking vessels both Etruscan and Greek, including the Rhodian wine-jugs from Kappel-am-Rhein and the Black-Figure jugs from the Heuneberg. The tradition of hospitality that was to play such a part in the Celtic pattern of living must have established itself very early, and wine imports on a great scale came by way of the Rhone and in more modest quantities no doubt by the direct routes from Italy. In exchange, the transalpine peoples had metals, amber and slaves to offer.

The vital elements in the mature La Tène style are that living quality of line and mastery of plastic form which could transform a mere personal ornament into an emotive work of art. This element is absent from the flagons we have been discussing. They still mirror the south, even if the mirror is a distorting one, and the same is true of similar-type flagons found at Dürrnberg in Austria and at Klein-Aspergle in Württemberg. Patterns on lid and neck and foot are beautifully contrived; but when scrutinised closely the details, whether palmette, Greek-key or interlace, betray their classical origin, although a novel, tasteful adaptation demonstrates how the Celtic artist never merely transferred or copied what he borrowed. In the last chapter I suggested that the elements

[1] For possible origin of the joint-spiral, see Jacobsthal, ibid., p. 45.

Fig. 12 DÜRRNBERG FLAGON, detail
Jacobsthal, *Early Celtic Art*

Fig. 13 PALMETTES, Parthenon
British Museum Guide: Iron Age

of the new style had been building up from the Hallstatt period, or even earlier, and that what the artists and craftsmen required was a sense of identity. With it they needed conscious purpose and direction, some dynamic unifying force, and these impulses arrived with the realisation by the Celts of their strength some time before 400 B.C., when they broke into North Italy and overthrew the power of the Etruscans—a movement with such momentum that the Celtic armies went on to the victory of the Allia (390 B.C.) and occupied Rome herself. Our schooling over the generations is such that we still think of this event as one of the great catastrophes of history, an irruption of barbarian hordes into the streets of a sort of Victorian world-capital, and wild men no doubt they were in their hour of triumph. But we should remember that a successful invasion of this kind could never have been mounted had there been no more than a lust for booty behind it. There must have been resolution and leadership of a high order, and a common sense of pride and purpose; in the wake of this the artists and craftsmen, like the bards, in their exultation would feel impelled to do great things.

If the debt of the Celts to classical ornament is manifest, some commentaries are coloured by prejudices that do not help to clarify the issues. There is, for example, the sweeping statement in Leeds' *Celtic Ornament* asserting that to the Celts Nature was almost a closed book.[1] 'Throughout their artistic history', he wrote, 'it is impossible to detect those natural powers of accurate observation, the lack of which must constitute an eternal bar to entry into the higher spheres of art, among which plastic art takes a leading place. Their treatment of the classical palmette proves that they were endowed with little appreciation of the natural world in which they moved, for they added nothing fresh.' It might scarcely seem necessary to refute an assertion of this kind, but there is still a tendency to call 'unnatural', or merely decorative, creations which are not photographically accurate representations of the externals of nature. On the question of the palmette, it does little service to the study of the deeper significance of Celtic art constantly to measure the developments of such derived motifs against the yardstick of the classical prototypes, because the Celt had no mind to copy. When Jacobsthal refers to the 'double palmette' on the handles of the Lorraine flagons he might equally well have called it a *jui* sceptre, a Chinese motif which it resembles more closely, although I am not suggesting any connection. One must avoid the temptation to see progressive debasement of classical motifs in Early Celtic art and look rather for the emergence of a vital new style.

What might be called the buds of this new flowering are beginning to form about the fifth century B.C. and throughout the fourth. Some beautiful examples occur on helmets left behind by early Celtic incursions to north Italy. The best and most complete, now in Berlin, was found at Canosa in Apulia. It is of iron with an overlay of bronze sheet embossed with a pattern of twining or flowing scrolls which exhibits some of that disciplined power which marks the best La Tène art. It must have been a splendid piece of headgear. In Jacobsthal's view a gold band formerly separated the two bronze areas, the design being picked out with coral inlays, and plumes waved from the tubular holders which project from the crown.[2] Also in Berlin is a casque from Umbria with hinged cheek-pieces, much in the Roman manner, and here again the design possesses a living quality, so that in its original state the helmet must have been arresting. In the Umbrian piece a vestigial palmette is centred in the 'lyre' ornaments at either side, but it is dwarfed by the lobes which flank it like uncoiling pythons. Two magnificent helmets preserved at Ancona show equal mastery of linear ornament in the form of intricate surface engraving. The British Museum possesses only a cheek-piece from a fourth- or third-century helmet. The disposition of bosses and scrolled connecting ornament is similar to that on the other helmets. The helmets may be relics of the Galates, who invaded in 390 B.C. The Celtic occupation of northern Italy extended as far south as Senigallia (Sena Gallica).

In this age of increasing domination by a successful warrior caste there is naturally a marked emphasis on weapons and military accoutrements, on feasting and hospitality, on ceremonial, on the adornment of women. The home of the new style seems to be the

[1] E. T. Leeds, *Celtic Ornament*, Oxford, 1923, p. 36.
[2] Jacobsthal, ibid., p. 180.

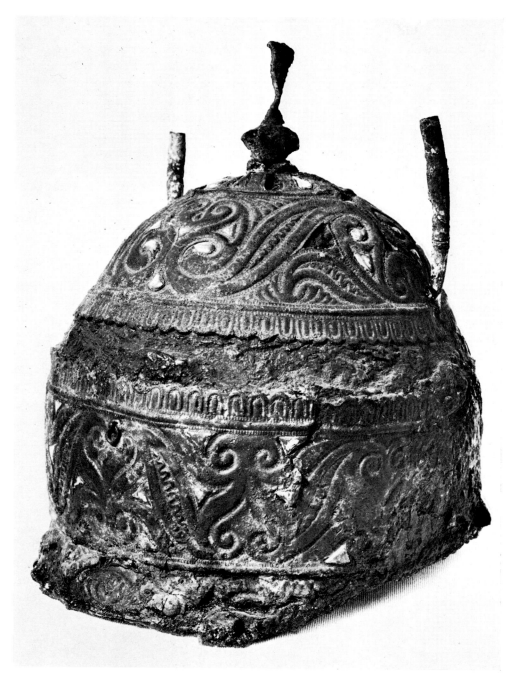

Plate 12 HELMET, bronze and iron, coral insets. Italy—Canosa, Apulia: late
4th–early 3rd centuries B.C. Height 25cm.
Staatliche Museen, Berlin

central Rhineland area, well to the north of the Alpine barrier. Here it appears on objects recovered from chariot-graves, showing it to be very much an aristocratic art, an art of the warrior-chieftain and his retinue. Not all these graves have produced examples of the new style, but the sumptuary environment which cradled it is always there. It is a time of transition. Thus we have the Schwarzenbach cup-mount already mentioned; we have a weapon like the sword from Weisskirchen at Mainz, classical in some of its detail; and we have the gold ornaments from the grave at Reinheim, near Saarbrücken, which are classified as Early La Tène of the beginning of the fourth century B.C. The Reinheim interment is known as the princesses' grave. It contained finger-rings and a neck torc with twisted hoop and elaborate terminals, in association with other things. The element of movement of the La Tène style is not so manifest in these ornaments, the most striking feature of

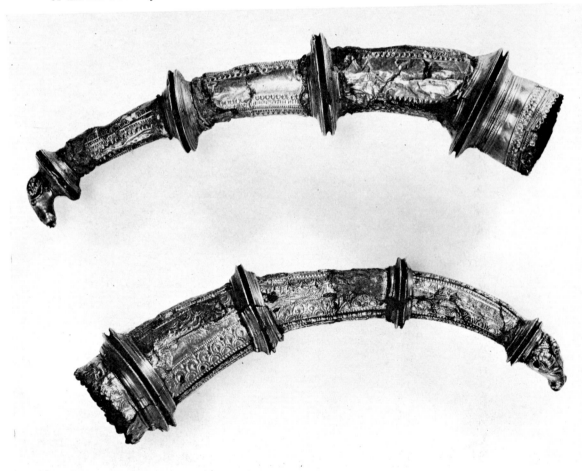

Plate 13 GOLD DRINKING-HORN TERMINALS. Germany—Klein-Aspergle, Württemberg: 4th century B.C. Length 14.5 and 17.5 cm. *Landesmuseum, Stuttgart*

which is the masks, especially the human masks. One of these has a hint of Etruscan feeling, at least in profile; but there is none of the dynamic assurance nor yet of the sophisticated delicacy of mature La Tène art. On the other hand, there can be great strength in this early work, for example in the execution of the gold ram's head terminals of the drinking horns from the grave at Klein Aspergle, preserved at Stuttgart. The craftsman had doubtless seen Greek rhytons of similar design—there were indeed two Attic cups in the grave—but there is now present that feeling for animal forms which is one of the most delightful attainments of Celtic art. There is Greek or Etruscan inspiration too in the beaked flagon from Klein Aspergle, embellished with typical little Celtic masks. This

Fig. 14　FLAGON, Klein-Aspergle. After Jacobsthal, *Early Celtic Art*

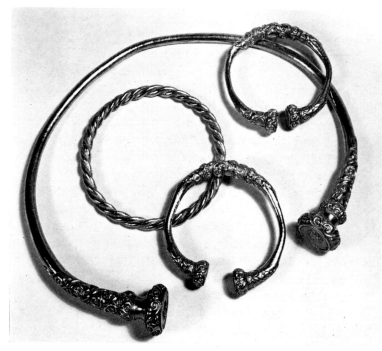

Plate 14　GOLD TORC AND BRACELETS. Germany—Waldalgesheim, Rhineland: about 300 B.C. Diameter (large bracelet) 18.7cm. *Landesmuseum, Bonn*

form of flagon became established both in bronze and in pottery as the *Schnabelkanne* seen in many museums, and the type seems to have continued in the Alpine region down to relatively recent times, as one may see in the Tiroler Volkskunstmuseum in Innsbruck. The quality of delicacy in the new art form is at once apparent in some of the objects from the chariot-grave at Waldalgesheim in the Landesmuseum at Bonn, which are slightly later in date than the Klein Aspergle or the Reinheim finds. The gold torc and bracelets are accomplished pieces, their ornamented areas carrying carefully calculated scrolls that cling to the surface like vine-tendrils, thrilling with life. Such decoration is

central to the La Tène style, and developed strongly both in Gaul and the British islands as the two following chapters will show, and it represents the popular idea of Celtic art. The Waldalgesheim discovery marks the beginning of maturity in the La Tène style and yet at the same time offers further evidence of Mediterranean inspiration. There were in the grave an imported bronze bucket, probably Campanian, of the late fourth century and therefore contemporary with the gold torc and bracelets, and also a bronze spout-flagon which Jacobsthal considers to be 'generations' earlier. The shape of the flagon is rather crude, but the terminal ornament of the handle and the pattern lightly engraved on the surface of the vessel have promise of the full flowering of the style. Here one can see how the Celtic craftsman took note of the palmette or honeysuckle handle terminals of those classical vessels like the bucket from Waldalgesheim but freely modified them to his own taste; and the pattern of opposed S-scrolls engraved on the surface of the spout-flagon has a resemblance to the classical lyre-motif which is no more than shadowy, because it is already developing a free life of its own that is to flower in the rioting patterns of the mature La Tène style. The new element inherent in the emergent new style of the Waldalgesheim gold-work is not easy to describe. It involves a rebellion against the symmetrical scroll-work on the surface of the flagon, or indeed on the gold-covered iron device from Klein-Aspergle, and a leaning towards asymmetrical patterns which, although stylised also, contrive to capture something of the 'careless rapture' of nature. After centuries of awkward conformity to southern notions, the northerner seems to show signs of impatience with formulae which are foreign to his nature and begins to seek expression for his wayward fancies. Sandars, in one of her perceptive commentaries, regards La Tène as a style as distinct as classical art or Egyptian.[1] No other 'barbarian' art compares with it. It is, she avers, 'more professional, surer of itself, appearing to accomplish what it sets out to do; and yet so unpredictable and idiosyncratic, so exactly poised and consistent, telling much and concealing much, anti-classical yet as disciplined as the best classical art'.

The discovery of so much of this material in war-chariot graves has reaffirmed its association with a Celtic aristocracy. La Tène art is commonly regarded as the creation of such an aristocracy. If this means creation through enlightened and appreciative patronage then it cannot be questioned. Reference has been made to the unifying and stimulating effect of the mounting spirit of military adventure, and the emergence of a princely caste brought this about. That the warrior chiefs enjoyed the arts is apparent from the growing aesthetic quality of the grave finds. An urban civilisation is not essential to produce magnificent, even sophisticated personal possessions. Nomadic Scythian chiefs were splendidly accoutred; Irish kings were rich in fine belongings; and in the eighteenth century Highland chiefs in Scotland set store on the quality of their costume, weapons and ornaments when they possessed little else. But the chiefs or princes were stimulators, not creators of the art-form. Powell wisely qualifies his remarks about an aristocratic culture with a pointer to the part played by native craftsmen in developing the style,

[1] Sandars, ibid., p. 226.

and he draws attention to the position of the craftsman caste in early Ireland, a caste that possessed privileges giving them much in common with the fighting man.[1] The extraordinary vitality of La Tène art, and its wide distribution in place and time, imply a kinship of craftsmen linking closely local schools from north of the Alps to Britain. Just how well organised socially or as a craft these men were is hard to assess except by reference to later periods; though the discovery in 1969 of what seem to be punch-marks on the blades of two swords of the second century B.C. in the original La Tène hoard, only then for the first time extracted from the scabbards, to which they had been bonded by rust, raises interesting possibilities. I am indebted to Dr Egloff of Neuchâtel for drawing my attention to this feature.[2] The *poinçon* on one of the two blades is much clearer and takes the form of what could well be a greatly stylised human head. It is not merely a decorative motif because it is isolated and rather casually positioned and would in any

Fig. 15
PUNCH ON SWORD-BLADE
Dr Egloff, Neuchâtel

event be obscured when the sword was in its scabbard. It could perhaps have some ritual significance, or even be a mark of ownership. Far more likely, however, is the tentative suggestion that these are the punches of the men who forged the blades, anticipating the armourers' marks of many centuries later and indicating that the La Tène armourers may have had some kind of organisation.

The pre-eminence of metal work among the arts continues, and the fluent, asymmetrical compositions which become dominant at this time are essentially bronze forms, stimulated by the plasticity of the medium. These compositions are two-dimensional, attempting nothing in depth. They are also limited in scale. It may be natural that scale should influence assessments of the importance of the art of any people, and lack of it has in some eyes jeopardised the Celtic achievement. Sandars wonders whether Celtic art is not 'too limited to be really great', but she wisely goes on to note its surviving influence long ages after, in medieval Europe.[3] Take away architecture and the more massive stone-sculptures from the accomplishments of the Egyptians, the Greeks, the ancient peoples of India or of South and Central America, and their impact diminishes out of all recogni-

[1] Powell, *The Celts*, London, 1958, p. 99.
[2] Annual report of Neuchâtel libraries and museums, 1969, paper by M. Egloff, p. 70. See also Powell, *The Celts*, p. 149.
[3] Sandars, ibid., p. 226.

51

tion. Why did a people as skilled as the Celts in fine metalworking attempt nothing in the sphere of large public works in stone? The natural material for building over most of the region occupied by Celtic tribes was timber, and if the Celts had their towns and their temples we have not as yet found evidence of anything that could seriously be called a timber style of architecture. Stone sculptures are not numerous, and it seems many of them were destroyed in medieval times for their connection with pagan rites. I shall deal in the next chapter with the interesting Gaulish group, but a few dating from about 400 B.C. have survived in the Rhineland. The best examples are in the Landesmuseums

Plate 15　CARVED STONE PILLAR. Germany—Pfalzfeld, St Goar, Hunsrück: about 400 B.C. Present height 1.48cm. *Landesmuseum, Bonn*

Plate 16　CARVED STONE FIGURE of 'Janus' type. Germany— Holzgerlingen, Württemberg: about 400 B.C. Height 2.45m. *Landesmuseum, Stuttgart*

of Bonn and Stuttgart. That the new art form is primarily a creation of the metalworker is affirmed by the lobes and scrolls which appear on the sculptures, for example the well-known pillar from Pfalzfeld in the Hunsrück, at Bonn. The ornament has not the easy flow of metal forms. This pillar is not carved in the round, but as four independent panels,

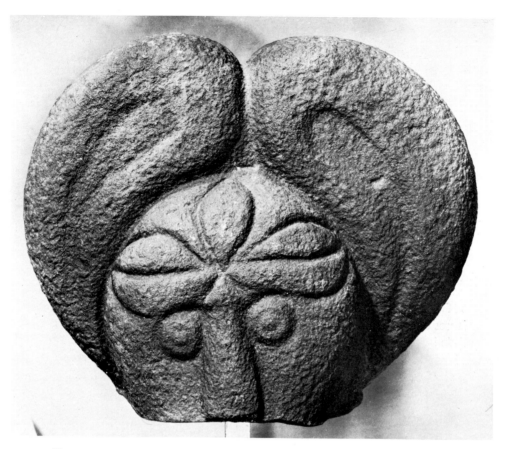

Plate 17 CARVED STONE HEAD. Germany—Heidelberg: about 400 B.C.
Height 31 cm. *Landesmuseum, Karlsruhe*

neatly divided by the cabled edges, showing that the sculptor, like the metal worker, thought in terms of decorated surfaces rather than a three-dimensional unity. The most significant feature, however, is the pear-shaped head set in each panel, surmounted by a pair of lobes suggesting a wreath. The lobes may be compared with those crowning the mask at the base of the Waldalgesheim spout-flagon. Such a combination of head and lobes in one form or another is a feature of this phase of Celtic art. The lobes appear again, looking somewhat like horns, on the head of the 'Janus' statue from Holzgerlingen at Stuttgart, as restored, and they are taken to represent a leaf-crown, characteristic of such cult statues. One of the best examples is that from Heidelberg, at Karlsruhe, and Powell suggests that such a head may have surmounted the Pfalzfeld pillar, a local tradition maintaining the pillar once possessed something of the sort.[1] The Heidelberg head is much more of a concept in the round, and has real sculpturesque quality. The Holzgerlingen statue, on the other hand, is a crude affair artistically. A certain crudity marks nearly all Celtic stone carving of the period, as the two following chapters will show.

[1] Powell, *The Celts*, p. 135 and fig. 24.

53

Quite apart from any question of artistic ability, it is interesting to speculate how patrons of the sophisticated metalwork looked upon the stone carvings. No doubt the sculptures here, as in Gaul, were made for sanctuaries, or at least had an element of the mystical in their purpose. The chieftain who caressed his wine-flagons or the lady who played with her intricate bracelets may have looked on the relative rudeness of the cult-statues as naturally evocative of fear and awe. Those La Tène leaf-crowned heads are assumed to be the heads of divinities. The Celts had a special cult of the head with somewhat gruesome implications, which will be referred to again in the chapter on Gaulish art, and the primitive nature of the sculptures may in some degree be deliberate and not merely a sign that the Celt's gifts as a sculptor were limited. Identification of the gods with human perfections was no part of Celtic belief: divinity was not an idealised man or woman on a podium in the temple; it was a presence in the oak-groves.[1] We are still prisoners of the anthropomorphism of the ancient world of the Mediterranean, which has had its part even in shaping Christianity. But the Celt was a child of nature, sensing rather than seeing divinity in natural phenomena, and although he was aware that the peoples beyond the Alps made statues of their gods and himself was drawn to do the same, he seems to have dehumanised the features of his images. He tended, as in the case of the Holzgerlingen statue, to leave them little but inscrutability, or to symbolise the god's all-awareness by giving him two almost identical countenances, facing in opposite directions, a type which archaeologists refer to as a Janus-image. Powell sees the four facets of the Pfalzfeld pillar as a like piece

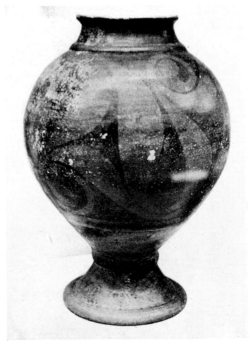

Plate 18
PAINTED EARTHENWARE VASE.
France—Prunay, Marne:
about 300 B.C. Height 31 cm.
*British Museum, London, by
courtesy of the Trustees*

[1] cf. Déchelette, ibid., p. 1509.

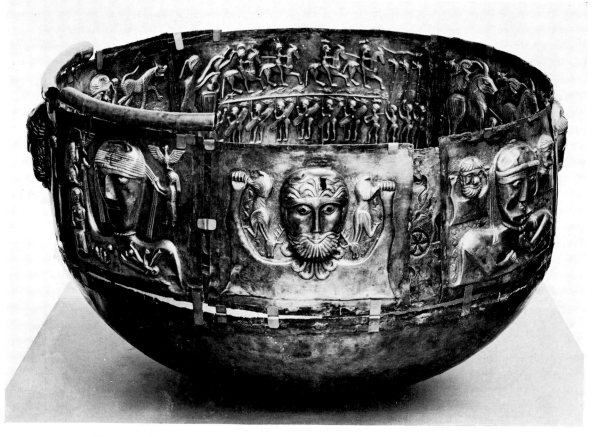

Plate 21 SILVER CAULDRON. Denmark—Gundestrup: about 100 B.C.
Diameter 69cm.
Nationalmuseet, Copenhagen

the fortunes of war.[1] Striking as its iconography is, the bowl is awkward and unsophisti-
cated beside simpler but more mature pieces, especially those of insular Celtic art, made
at a safer distance from the disturbing impact of the oriental world, and its general aspect
is much less Celtic than its details. It is, as Sandars says, 'eclectic',[2] but with none of the
masterly power to co-ordinate the contributory elements as an elegant whole.

There is a curious absence of monumental sculpture in the south-east: curious because
in Bohemia there is one example accomplished enough to lead us to expect others. This
is the head from Mšecké Žerovice, now in Prague. Though the only one of its kind found
east of the Rhine, it is not an imported piece, and is carved from a local sandy marl. It
has been called the head of a chieftain and there may be an element of portraiture, if the
features are strongly stylised. Untouched by classical influence, this head exhibits the

[1] P. V. Glob, *The Bog People*, London, 1969, p. 178. ('In 113 B.C. the Cimbri from Jutland
invaded Celtic Bohemia'—see Powell, *The Celts*, p. 162.)

[2] Sandars, ibid., p. 253.

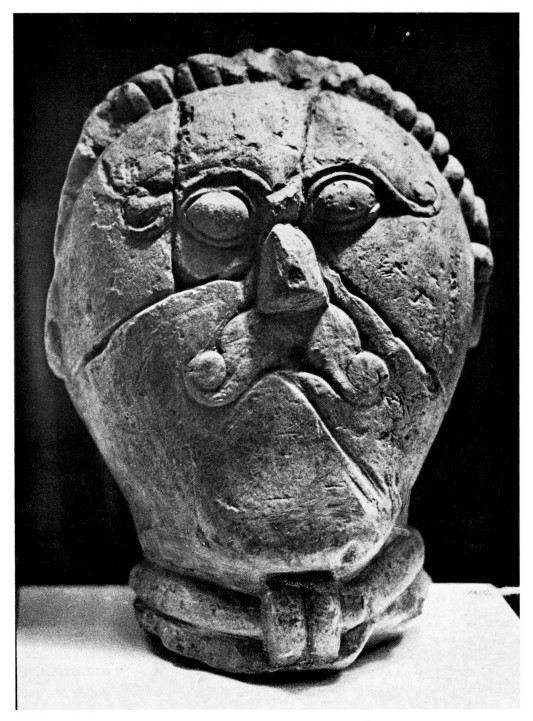

Plate 22 CARVED STONE HEAD. Czechoslovakia—Mšecké Žerovice: 3rd–2nd
centuries B.C. Height 25cm.
Národní Muzeum, Prague

characteristic bulging eyes defined by ridged outlines, the wedge-like nose, the small, pursed slit mouth, the swept-back hair. Eyebrows and moustache are given curling ends which match. Produced just before 100 B.C., at a time when Celtic power was at its peak and technical accomplishment advanced, it provides further evidence of the Celtic artist's attitude to the portrayal of human subjects. The masterly ability with which animals and birds were reduced to their salient features and rendered with certainty and strength is apparently inhibited in human portraiture. There will be further discussion of Celtic sculpture in the next chapter, for there is so much more of it in Gaul; but this strange head compels a warning against hasty judgments employing the criteria applied to classical or even oriental sculpture. Classical art has been described as 'organising, ordering, centripetal'. The Celtic artist, swayed by emotions and impulses and dreams, baffled perhaps by things inexpressible, had recourse to symbolism. Flights of fancy occupied him and often he could only express them through a sort of inspired doodling. As an artist, his supreme problem may well have been the human face, challenging him to the realism which he generally preferred to avoid, and this too he tried to reduce to a kind of symbol, a mask. Indeed, until the Roman occupation of Gaul, masks were as near as the Celt came to escaping his traditional convention; at times he achieves a rather brilliant result, as with the Kladno piece. Where animals are concerned, he had no inhibitions about naturalism. Although constantly working within certain stylistic conventions he bends these to express the character of the animal. Here in Bohemia he catches superbly in his

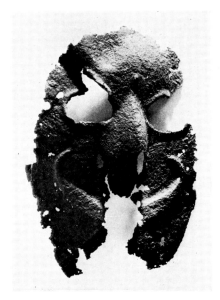 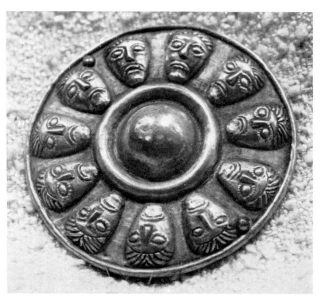

Plate 23 IRON MASK. Czechoslo-
vakia—Kladno: probably
2nd century B.C. Height 22 cm.
Regional Museum, Kladno

Plate 24 SILVER DISC with masks. Italy—
Manerbio sul Mella, Brescia: 3rd–
2nd centuries B.C. Diameter 9 cm.
Museo Civico Romano, Brescia

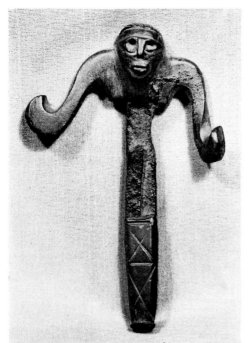

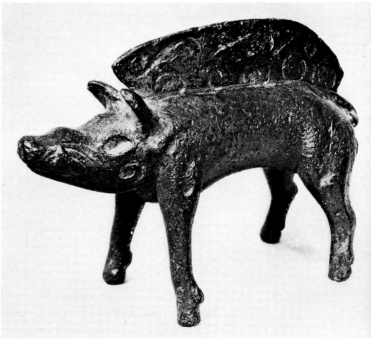

Plate 25 BRONZE AND IRON LINCH-PIN. Germany—Grabenstetten, Württemberg: 4th–3rd centuries B.C. Height 12cm.
Landesmuseum, Stuttgart

Plate 26 BRONZE BOAR. Hungary—Báta: 1st century B.C.– 1st century A.D. Length 10.6cm.
Nemzeti Muzeum, Budapest

miniature bronzes the spirit of wild things, showing a faculty inherited from much earlier times and transmitted to the insular schools. The deer head from the Taurus illustrated by Jacobsthal is a notable example. The long, curving neck is abstract, yet alive, the head is of the very essence of the animal, an impression unattainable by anyone who had not put up a doe from a covert. The coursing dog in the British Museum is nearly as perfectly observed, its drooling muzzle and lolloping paws deftly indicated. Most of these animal studies were made not as independent studies but as adjuncts of something practical, for instance the handle of a flagon, as the dog certainly has been. They have served as secondary features, like the wolf creatures on the Lorraine flagons; or they may have been votive figures, like the little boar from Báta in Budapest, token of a cult common to the Celtic peoples.

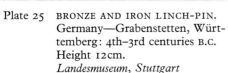

Fig. 17
BRONZE DEER HEAD, Taurus
After Jacobsthal, *Early Celtic Art*

IV

The Heroic Age (2)
The Gauls

Many fine pieces in the La Tène style were made in the region known to the Romans as Gaul. If Caesar and other Roman writers give the impression that this people was a single nation, a Celtic nation, the Gauls were in fact confederations of tribes occupying what is now France, as well as the north-east of Italy, where for long they traded with the Etruscans.

The art of Gaul is inspired in the main by the same spirit as that of other Celtic regions, but has certain special characteristics. Pobé and Roubier think the native Neolithic and Bronze-Age peoples had a considerable influence on the incoming Celts,[1] who seem to have taken over some of the ancient Stone-Age holy places, the menhirs and megaliths, if finds of Gaulish and Gallo-Roman artifacts of later date on the sites are significant. In southern Gaulish art one must guard against expecting any massive element of the native culture. The ultimate formative influence is the culture of the Mediterranean and the oriental ideas and motifs conveyed through it, here more directly exerted than elsewhere in the Celtic world. Massilia (Marseilles) was from early times a Greek colony. Through this colony, and deep into Celtic territory by way of the rivers Rhône and Durance, poured an endless traffic of Hellenic things. Other river-systems such as the Loire and the Seine carried classical influence even further across Gaul, although René Joffroy, discoverer of the Vix treasure in the remarkable museum at Chatillon-sur-Seine, tells me he believes the Hellenic imports found with the treasure to have come by way of Switzerland.

In the immediate area of Massilia the Celtic incomers seem to have formed a union with, and dominated, the native Ligurian stock. The evidence of the ruined *oppida* and fortress towns of this area suggests a formidable development of 'barbarian' strength, for in the second century B.C. the Romans felt it necessary to destroy utterly two of the towns, Entremont and Roquepertuse. One may infer that they were politico-religious centres of resistance. Their special interest in the context of this book is that they were also centres of a school of sculpture associated with rituals probably common to the Celtic peoples everywhere, though here rendered rather more articulate through glyptic techniques learned from the imported classical pieces. Perhaps the most significant single feature of this school of sculpture is what the French term the *tête coupée*, the dismembered head,

[1] Marcel Pobé and Jean Roubier, *The Art of Roman Gaul*, London, 1961, p. 1 et seq.

63

evidently connected with a gruesome cult. The cult seems to have been practised in the sanctuaries, and references and hints by classical writers to bloody ceremonies in the sacred oak-groves are borne out by what has been found in the ruins of certain Celto-Ligurian temples. The door-frame or portico from one of those temples, at Roquepertuse, now in the Musée Borély at Marseilles, has square pillars of local limestone with shaped niches made to contain human skulls, and at the sanctuary of Entremont fifteen skulls were recovered which had been so exposed. At least one classical writer speaks of his

Plate 27 PORTICO OR DOOR-FRAME, limestone, from Celto-Ligurian sanctuary: replica, as mounted in exhibition 'Early Celtic Art' at Royal Scottish Museum, 1970. France—Roquepertuse, Bouches-du-Rhône: 3rd–2nd centuries B.C. Height 1.19m. *Original in Musée Borély, Marseilles*

disgust at the Celtic habit of decapitating slain enemies and hanging their heads at the victor's doorpost. If we accept this, as probably we must, then the skull niches at Roquepertuse were no doubt for slain enemies. Associated with the cult of the skull is the multiplicity of sculptured stone heads in the Celto-Ligurian towns. They occur most commonly in relief, sometimes in the round. In certain cases, as in the 'Hall of Heads' at Entremont, the sculpture is in an embrasure like the skulls. At first sight there is a certain crudity in such heads, and it is tempting to say the sculptor had achieved no great competence, but the sureness of modelling gives one pause. All follow a broad pattern, a pattern to which nearly all Celtic representations of heads approximate, no matter where they occur. It is discernible in the Pfalzfeld pillar and other sculptures

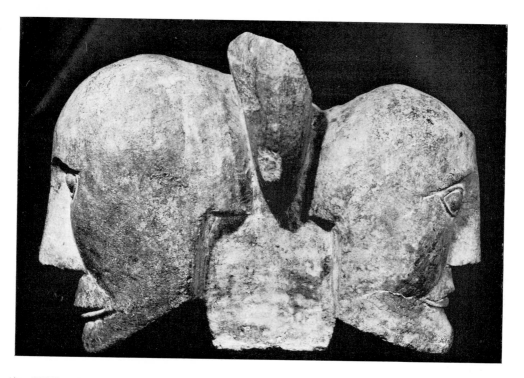

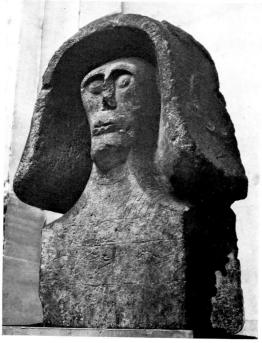

Plate 28
CARVED LIMESTONE 'JANUS' HEAD.
France—Roquepertuse, Bouches-du-
Rhône: 3rd–2nd centuries B.C.
Length 34cm.
Musée Borély, Marseilles

Plate 29
CARVED LIMESTONE HEAD WITH
HELMET. France—St Chaptes, Gard:
3rd–2nd centuries B.C. Height 51cm.
Musée Archéologique, Nîmes

already described: a pear- or wedge-shaped face, a wedge-like nose, a slit mouth, generally small, and eyes which in depicting the living tend to be large and staring, slit-like when they seem to belong to the dead. Sometimes, as in the case of the 'Janus' head slowly revolving on its turntable in the Musée Borély, the conventional rendering attains a curious distinction, almost the inscrutable beauty of a Gandhara Buddha, if without the compassion. Humanising details are few. Hair may be indicated, and a hood or coif if the subject is a woman, a vast projecting helmet if a warrior, as the two busts in the Archaeological Museum at Nîmes. Such pieces are all the more impressive since the Celt seems to have had no tradition of stone sculpture and must have found the quantities of sophisticated work that poured in through the port of Massilia both alien and baffling. One can sense the struggle between wonder at the realism which confronted him in Greek and Roman pieces and his instinct to be devious and abstract; and again druidical ritual may have demanded the brooding and even fearsome aspect which some of the heads achieve.[1] They date from around the third century B.C. That the Celt had familiarised himself sufficiently with the technique of stone-carving, at least by the second century, to express with some naturalism his feeling for living forms can be seen in the

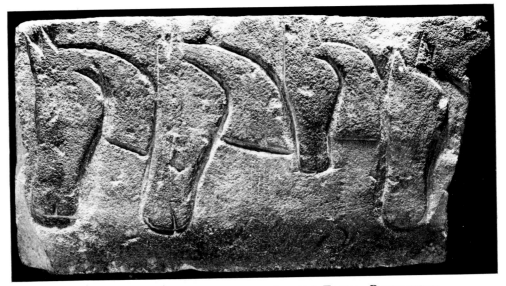

Plate 30 LIMESTONE CARVING OF HORSES' HEADS. France—Roquepertuse, Bouches-du-Rhône: 3rd–2nd centuries B.C. Length 60cm.
Musée Borély, Marseilles

frieze of horses alternating with heads on the door-lintel from Nages at Nîmes, or in the splendid frieze from the Roquepertuse sanctuary at Marseilles. It seems probable that the inculcation of fear by means of gruesome representation had a part in the rites of the sanctuaries, and visually the most convincing proof of this is the stone group known as the

[1] Stuart Piggott, *The Druids*, London, 1968, pp. 116–118.

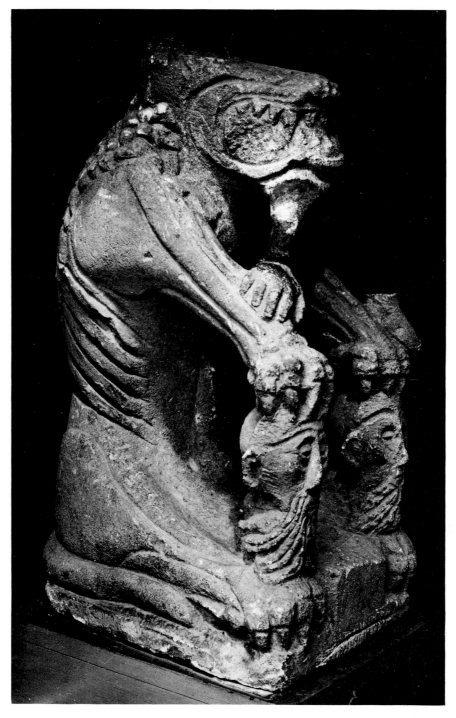

Plate 31 SANDSTONE CARVING KNOWN AS 'TARASQUE DE NOVES'. France—
Bouches-du-Rhône: probably 1st century B.C. Height 1.12m.
Musée Calvet, Avignon

Monster of Noves (*Tarasque de Noves*) in the Lapidarium Calvet at Avignon. Here too there is an element of crudity in the execution, but the rudeness is effective, emphasising the horrific aspect of this creature from whose mouth a half-eaten limb protrudes and whose terrible claws rest upon a pair of bearded heads of victims of this symbol of death.

Figure sculpture, apart from heads, is scarce. The most important pieces are two seated figures from Roquepertuse, now at Marseilles. Dating from the third century B.C., they are formal pieces representing tribal heroes or perhaps gods, and sit in a characteristic cross-legged posture—Diodorus records the Celts as feasting sitting on the ground

Fig. 18 STONE FIGURE,
Roquepertuse
After Jacobsthal,
Early Celtic Art

Fig. 19 CERNUNNOS,
Gundestrup cauldron
After *catalogue cover, exhibition*
'*Early Celtic Art*'

—wearing a short robe, in one case with indications of a diamond pattern. The other figure wears a torc and an arm-ring. Both are headless, no doubt as a result of the Roman sack of the town. There is little attempt to imitate classical figure sculpture, and torso and limbs are modelled without any particular regard to anatomy. Indeed the statues have a hieratic quality reminiscent of Egypt, although of course this is purely coincidental. Squatting figures are represented fairly widely in Gaul and elsewhere in Celtic regions. The god Cernunnos is depicted in a posture of this kind, for example on the Gundestrup bowl and in small bronze figurines such as one in the Römisches-Germanisches Zentralmuseum in Mainz. How far the requirements of religious ritual influenced Celtic artists is difficult to estimate and is largely a matter for speculation. If deities were identified with natural objects such as great trees in sacred groves then anthropomorphism probably came about but gradually under the influence of images from the south. One can think of the Celtic world as resembling the world of Professor Tolkien's 'Ring' cycle, the sacred

Plate 32 CARVED WOODEN FIGURE.
France—Sources-de-la-
Seine, Côte d'Or: 1st
century B.C. Height 86cm.
Musée Archéologique, Dijon

Plate 33 CARVED SANDSTONE FIGURE.
France—Euffigneix, Haute-
Marne: probably 1st century B.C.
Height 30cm.
Musée des Antiquités Nationales,
St Germain-en-Laye

groves taking on the awe-inspiring features of his Mirkwood and individual trees the sinister character of his willows. To introduce human imagery could be the beginning of the end of belief in such a cult. The wooden sculptures now at Dijon excavated in recent years in the Gallo-Roman cemetery at Sequana (Sources-de-la-Seine), and doubtless at one time widespread in their occurrence, vary in their aesthetic appeal but were in any case more or less rustic efforts. Possibly they were votive offerings. Some represent parts of the human body, even internal organs, and may have been involved in therapeutic magic. Others could be pilgrims, and the figure of a woman at Dijon has hints of a Tanagra mourning lady, yet also suggests the Janus statue from Holzgerlingen in the posture of the arm. Maybe in some cases the wood itself was of as much significance as the shape it was given. The tree had special properties—the word druid seems to mean one who has 'knowledge of the oak'—and there may even have been some sort of priestly taboo on the artist's imposing his will upon the material, or giving it familiar human shape. It is difficult for us to reconcile beliefs and idols which seem primitive with orna-

ments, weapons and household vessels that were often as refined and sophisticated as any in the ancient world. The chieftains and their women had taste and discrimination, but superstition could have made them see sacred stones and trees in a different light. When looking at the early stone sculptures of Celtic Liguria one must remember there is more in them of the wooden figures of prehistoric Gaul than of any imported classicism, and so judge them. The Celt has always been ambiguous, one who speaks in riddles, and it is more than likely that the interpreters of the sacred mysteries willed that deities should remain half-enshrouded in their matrices of stone or wood. It is not until the Romans dominate Gaul and reduce her to a province that her gods are reduced to the simulacra of men and women.

Whatever taboos influenced representations of the human form do not apply to animals, which also had their parts in sacred rites. The stone figure from Euffigneix, Haute Marne, at St Germain-en-Laye, is an interesting illustration of this problem. It seems to be a tribal god-effigy. The human head is characteristically remote and inscrutable, the figure only partially emerges from the material, even the torc round the neck is perfunctorily carved; but the boar relief on the chest is in a different spirit, stylised yet splendidly bristling with life, and the execution is crisp and done with complete mastery. One must conclude that if divinity was considered virtually unportrayable, the animals that were attributes of divinity were to be drawn faithfully, subject only to certain conventions, certain stylised features that probably had a magical rather than an aesthetic purpose; and this magical purpose may find some corroboration in the survival of those features, just like superstitions, far into the Christian era. Various animals, the boar among them, were venerated throughout Celtic Europe. The bull is another sacred animal. Bull sacrifices were part of the rites of divination, possibly one of the scenes enacted on the Gundestrup bowl. Artistic treatment ranges from stylisation, as on the bowl, to the superb naturalism of the almost monumental animal from Lillebonne at Rouen. Some of the bulls are three-horned. Horns were attributes with a special significance, and in one form or another appear on cult figures all over the Celtic world. The stag is another cult animal frequently portrayed, as indeed it was among the Scyths and throughout Siberia. Again the Gundestrup bowl can be taken as an illustration, depicting Cernunnos himself wearing antlers and bearing stags in his hands, perhaps in his capacity as Lord of the Beasts, perhaps simply because the stag happens to be his animal. In Gaul the stag figures both in reliefs and in the form of small bronzes, one of the largest and most important of them a somewhat stiff rendering in the Musée Orléanais, realistic enough for it to be recognisable that the antlers are 'in velvet'. The horse is often represented, as one might expect. Its significance among the Celts has already been described, and in Gaul the *equites* were second only to the druids in importance. It is also a cult animal, and worship of the horse-goddess Epona throughout Gaul is reflected in the arts. The appearance of the horse on coinage requires special mention.

The silver coinage of Greek colonists in Massilia is the model for the coinage of southern Gaul, although neither this nor the gold coins coming through by way of the

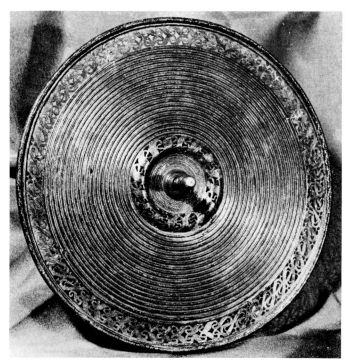

Plate 37 BRONZE PIERCED ROUNDEL, from harness. France—
St Jean-sur-Tarbe, Marne: 5th century B.C. Diameter
24.5cm.
Musée des Antiquités Nationales, St Germain-en-Laye

Plate 38 BRONZE HAME-MOUNTS. France—'La Bouvandeau', Somme-
Tourbe, Marne: late 5th century B.C. Length 18.3cm.
Musée des Antiquités Nationales, St Germain-en-Laye

to mind the revolutionary abstractions of the goldsmith Adam van Vianen in seventeenth-
century Holland. Also at St Germain there is a magnificent bracelet from the Tarn. Here
also we have those swirling forms, but each is fitted into a matt background with roped
edge.

The flamboyant, vital spirit of La Tène strongly influenced the native Gaulish potters.
As further east, classical wares were undoubtedly sought after by rich patrons in Gaul,

coming in as they did with imported wines. However, the native wares are of high quality, and some are decorated with marvellous assurance and an air of sophistication. Some shapes still show their metal ancestry in their angular outlines, but the potters are emerging from this imitative phase, and certain types such as the pedestal urns have pure ceramic form. Classical influence is still there, especially in earlier wares such as the bowl from Marsan (Marne) in the British Museum. Not only is there a Greek-fret painted design; in addition the pigment resembles the brownish-red glaze of Ionian pottery, as Jacobsthal says. Déchelette suggests that the occurrence of painted decoration was the result of Greek and Etruscan influence, as it belongs specially to the area most accessible to the south, but that the pottery shapes were Gaulish in origin.[1] Incised patterns belong to areas further north as one would expect.

This is perhaps the place to make a first brief comment on the achievement of the La Tène artists, as seen in Gaul. We have to face the inevitable dictum that their art is purely decorative. Such renowned authorities as Paul Jacobsthal and E. T. Leeds both seem to rest content with this assessment. Anyone seeking to find a deeper meaning beneath all the beauty and the skill has a difficult case to argue because he is dealing with an irrational, elusive people and, as far as the early period is concerned, an inarticulate people. Much of what the artists are trying to express can only be guessed at. With the passage of two thousand years abstract art can only begin to be understood after careful piecing together of the background, and there is no contemporary literary framework on which to build. There is nothing in fact until the Irish and Welsh literatures of much later times, as we know. Even Pobé and Roubier, writing of Roman Gaul, turn to the poetry of the Welsh bard Taliesin[2] and there seems no good reason to doubt that the thoughts of the La Tène artists are similar to those underlying lines that sing of delight in the kingfisher and the salmon and all living things, and of pride in valour and conquest. The unerring mastery of animal attitudes and character, so much profounder than the mere skilful copying of anatomy, comes from that intense feeling of oneness with wild things from which comes so much Celtic verse of all ages; but then again the grisly sculpture of Roquepertuse and Entremont stems from an equally undying strain that later emerges in literature in the bloody deeds and boasts of heroes. The artists of the La Tène epoch were eloquent after their fashion. Their flamboyant fancies would have the same power over their contemporaries as the plucked strings of the harps of the bards. Indeed, music is the parallel which always occurs to me in trying to interpret the work of Celtic artists. Music is essentially abstract yet, in one form or another, has meaning for almost everyone. What is perhaps less easy to understand is the sort of abstraction that underlies work of less obvious technical ability and taste than the metalwork. However, one must, I think, believe that a sculpture like the Euffigneix boar deity had quite as much power to strike awe into the Gauls as figures of Thoth or Anubis had to move the Egyptians, and if we judge it as a work of art we must be careful not to separate in our

[1] Déchelette, ibid., p. 1458 et seq.
[2] Pobé and Roubier, ibid., p. 37.

minds the superbly skilful boar relief from the apparently rudely executed anthropo-
morph, for the two are inexorably one, the rude stone being the sacred matrix upon which
the sculptor has cut his symbol of divinity. Even in Gaul, once the heartland of Celtic
power, surviving examples of art are relatively few and small in dimension, and those few
so incomprehensible to us that we are apologetic in suggesting anything to be a master-
piece. We have to take a great deal on trust. A fuller assessment can, however, be arrived
at after examining the work of the insular schools.

Southern France is, of course, rich in monuments of the Roman domination. They
range from great works of civil engineering such as the Pont du Garde to triumphal arch-
ways like Germanicus' at Saintes and temples like that of Augustus and Livia at Vienne or
theatres as at Arles. With those goes a great amount of stone sculpture. Between such
remains and the works of the native Gauls themselves in their own idiom there are
hundreds of transitional pieces through which the growing ascendancy of the legions and
the administrators who followed them can be traced.

Classical influence long anticipated the conquest, as we have seen. Such pieces as
the celebrated lion of Arcoule (Musée Reatlu, Arles), show Celtic notions of oriental
creatures seen through Greek spectacles, and the rather beautiful woman's head from
Entremont, now at Aix-en-Provence, in the modelling of its facial planes betrays aware-

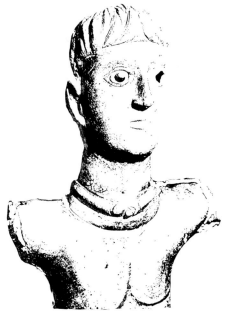

Fig. 21 LION OF ARCOULE
 After Pobé and Roubier,
 Art of Roman Gaul

Fig. 22 SQUATTING GOD, Bouray
 After Pobé and Roubier,
 Art of Roman Gaul

ness of Greek models. Again, at St Germain, there is the curious figure of the squatting god from Bouray, a Celtic deity whose head and torso reveal knowledge of classical forms. Within a century or two Celtic sculptors were attempting symbolic compositions such as the horsemen crushing giants at Epinal and Vichy, groups that may represent the defeat of evil chthonic forces. The concept is alien indeed. To make dreams and allegories live in human shape requires more genius than was given to the provincial imitators copied by the Gauls, and unerring Celtic taste could not do more than fumble with this unsubtle stuff. Even more unhappy is a work like the statue of Epona, the horse-goddess, at Alise-St-Reine in the Côte d'Or. The inevitable end of all this is the Cernunnos relief in the Museum of the Basilica of St Remy at Rheims, where the Celtic god is rendered in Roman accents and has Apollo at one elbow and Mercury at the other, or the Celtic goddess with a cornucopia going hand-in-hand with a dumpy Mercury, at St Remy-de-Provence. Ancient formless presences from the oak-groves have come forth to seek uneasy habitation and shape in stone and have merged their identities in such members of the Roman pantheon as seem superficially to resemble them, and soon a dead, provincial classicism has taken over the Gaulish sculptor's naive and fumbling approach. All this is outside the scope of the present book. It has been covered admirably by Pobé and Roubier. The main importance of Gallo-Roman art in a study of Celtic art is that the new era of representational sculpture does give us glimpses of what the Gauls looked like and how they garbed themselves, as in the manacled prisoner on the arch at Carpentras (Vaucluse) or the splendid armed warriors in the Lapidarium Calvet at Avignon. That the native feeling of the Gauls still expressed itself in lesser works is obvious from the numerous stone carvings and bronzes of animals, although a tendency to greater refinement, even to sentimentality, may distinguish later pieces from the earlier animal studies.

The later phase of Gallo-Roman art falls within the Christian era. In Gaul, Christianity came as the official religion of an empire which had already imposed its institutions and its culture upon the natives over the centuries, and as the empire itself became enfeebled the art forms sustained by it in turn grew feebler. The sculptures in the Christian Lapidarium at Arles and elsewhere in the south, although they have a character of their own and rank, many of them, as no mean works of art, are nevertheless pale shadows of the classical tradition and offer no promise of a renaissance. There is in them nothing of the native style. Perhaps the Gaulish winter was not severe enough to discourage the growth of the exotic Christian iconography and so bring forth a new hardy flowering upon the ancient wood.

may well have been 'parade' armours, although I doubt whether the absence of sword-marks is good evidence of this and have a feeling that a Celtic chieftain may not have differentiated between parade and war in these matters. One of the pieces generally believed to be for ceremonial purposes is the head-piece for a horse found at Torrs in Galloway, now in the National Museum of Antiquities of Scotland in Edinburgh. It is a superb illustration of the *repoussé* work of the Northern school. Distribution of the design is symmetrical and so must have been laid out with precision, yet it gives the impression of spontaneity and two of the scrolls grow into those bird heads which reach far back into earlier times, a feature seen even better in the beautiful shield boss from the Thames at Wandsworth.

Plate 43 SHIELD BOSS, bronze. England—London, Wandsworth: 1st century B.C. Diameter 38.2 cm.
British Museum, London, by courtesy of the Trustees

A marked feature of the insular schools is the high proportion of asymmetrical ornament. One exception is the great Battersea shield already described, which in its perfect symmetry is classical, although in its inspiration it is quite otherwise, with restless movement in every detail. An impulse towards asymmetry is found in all Celtic Europe from the Bronze Age onwards, and the incised tendrils on the Torrs pair of horns are anticipated by a spear from Lake Neuchâtel. Sandars has provided us with some of the most penetrating comment on a subject so involved and baffling that we can never know the answers, and she rightly stresses the bond of 'spiritual language' and 'accent' between artist and patron that made these works instantly meaningful as well as beautiful.[1] In

[1] Sandars, ibid., p. 277.

asymmetry expression was released to fly beyond the trammels of classical decorative convention, so that in the hands of the Celt, and perhaps especially the insular Celt, decoration had all the power of representational art. This is abstract art of the most remarkable kind. The would-be 'abstract' artist of to-day would do well to pay close heed to it: should note especially its perfect discipline, its faultless harmony which even the uninitiated can appreciate, its stern standards of craftsmanship, but above all else the common language which it spoke, a language rooted in nearly-forgotten folk tradition which waywardly causes a tendril to sprout into a bird's head.

The importance of colour for the emotional Celt becomes apparent early, but his sensitivity and subtlety demanded a high level of technical accomplishment. The insular schools eventually developed the art of enamelling to such a level. Enamel had begun to replace the old coral inlays in the third century B.C., and the artist became aware that if colour was to play its full part in the liquid, elusive designs in which he delighted it must be conveyed in some fully plastic medium. Vitreous enamel is assuredly such a medium. Mastery of its technical problems, however, took a long time. At first the vitreous substance was merely floated on to metal surfaces hatched to form a key. Later came the *champlevé* method of cutting compartments in the surface, into which the powdered

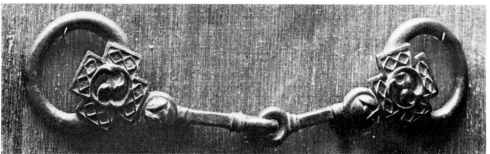

Plate 44 (*above*) HARNESS-TRAPPINGS, cast bronze. England—
Melsonby, Yorkshire: 1st century A.D. 7.5 and 8cm.
British Museum, London, by courtesy of the Trustees

Plate 45 (*below*) HORSE-BIT, bronze. England—River Thames: 1st
century A.D. Length 31.5cm.
British Museum, London, by courtesy of the Trustees

enamel could be fused, and there seems to be reason to believe the insular schools were pioneers in this method, which Sir Wollaston Franks went so far as to call *opus Britannicum*.[1] Red was the first colour used, derived from oxide of copper, in a medium of flint glass, and the Celts were obviously appreciative of the beauty of the burnished copper surface gleaming through the translucent enamel. Yellow, blue and other colours were introduced, some considerably later. On horse-trappings enamel was usually still confined to small, stud-like areas and was tentatively used, as with the bridle-bits from the Hull area in the British Museum and from Birrenswark in the National Museum of Antiquities of Scotland; but on such a piece as the harness-mount from Polden Hill in the British Museum the red enamel gives fire and life to an exquisite little ornament which otherwise could have been appreciated only through close scrutiny.

These accoutrements of war of the insular schools are the climax of the princely or chivalric trend which we have traced from the beginnings of Celtic art. Here is Early Celtic art in its full maturity. Here we see the Celtic artist at the apex of his achievement, both in techniques and in interpretation, and he is working for a patron whose pride needed the artist as much as the bard. Attention has already been drawn to the abstract quality of this art. It is almost as baffling to penetrate its meaning as to speculate about the epics which have not come down to us from the pagan bards. One can however deduce a good deal about the kind of men those artists and their patrons were, and no one has probed their attitudes more sympathetically than Dr Françoise Henry. As she remarks, the dominating factor in Celtic art is the desire to escape from two extremes: on the one hand, an exact imitation of living shapes, on the other the rigidity of geometric figures. 'These perpetual oscillations', she asserts, 'are the essential cause of its fluidity and elusiveness.'[2] Always there is tension: a sense of the dynamic, as Fox says, 'on the leash'.[3] Exquisite as the balance and distribution of the patterns are, they are not so much contrived as inspired, filling given spaces like restless liquids, constantly expressing the artist's delight in his medium and tools. The classical artist imposed his will on his material, transmuting marble to the semblance of human flesh, turning bronze into the symbols of human pride; but the Celt, quite as adept in his craftsmanship, surrendered to his emotions, even to the sensuous joy of the creative act itself. Arnold, writing of Celtic literature, lauds its marvellous sensibility, while regretting the Celt was not more master of it.[4] Yet in passing he confesses this sensibility could be the root of chivalry and romance and the glorification of a feminine ideal, that it brings him close to divining the mystery of nature. All art is in equilibrium, but the Celt's is the equilibrium of the tight-rope-dancer, obeying a law certainly but a law discernible only through the senses. To try to reduce Celtic ornament to a geometry is to destroy it. The running scroll, a basic motif of this period of La Tène art, could all too easily be reduced to a diagram of geometrical character, with no quality of life; the Torrs pony-cap is one of many creations

[1] J. Romilly Allen, *Celtic Art in Pagan and Christian Times*, London, 1904, p. 137.
[2] Françoise Henry, *Irish Art*, London, 1940, p. 190.
[3] Fox, ibid., p. 141.
[4] Matthew Arnold, *On the Study of Celtic Literature*, London, 1867, p. 107

which illustrate the unerring awareness with which the artist evades monotony by a sudden surge of exuberent emphasis, even by puckishly twisting the tail of a spiral into something resembling a living creature—bird, fish or leaf. The most rigid and constricting of areas could not confine his fancy or regiment his taste, of which there are not better examples than the sword-sheaths from Lisnacroghera in Ireland and from Bugthorpe in Yorkshire, in the British Museum—on which the ripple of most delicate engraving ends in a perfect foil, the richly-moulded chape. The entire area is 'busy' here, yet nowhere is the decoration overdone. Despite what is sometimes said, the Celt knows better than most the value of contrast between ornament and reserved ground. Sometimes—the Roman-type helmet in the British Museum and the crescentic plaque from Llyn Cerrig Bach, Anglesey, in the National Museum of Wales are instances—there is no ornament but one wild trumpet-blast in bronze, proud as the shogun's crest on a Japanese head-piece, and perhaps of similar significance.

Fig. 24 LISNACROGHERA SCABBARD
J. Romilly Allen, *Celtic Art*

Fig. 25 MOTIF FROM BRONZE PLAQUE,
Llyn Cerrig Bach, Anglesey
After photograph

Although there are several insular schools, and Fox has pursued their characteristics with great industry and discernment, a similar spirit permeates them all. One, however, the south-western school, has given us a group of pieces which complement the martial material which forms such a large part of the Celtic *oeuvre*. These are the mirrors, a disproportionate number of which seem to have originated with this school. The mirror, in its way, is as evocative as the sword. If one is a symbol of knightly honour, the other reflects the graces and virtues of woman, and the craftsmen of most of the great civilisations have therefore lavished their talents on both. The Celt, with his peculiar sensibility, created the most delicately beautiful and significant mirrors of all. Even the T'ang bronze-workers of China, for all their exquisite artistry, often chose subjects for their mirror-backs more attuned to the temple or the chase than to the boudoir. The mind of the Celt was subtler and more *galante* than any courtier of the Louvre, and he would never have offered his lady an instrument for her toilette encrusted with masculine imagery. The very shape of the mirror is not an obvious circle; it is a gently-depressed variant, which aids the balance, and the moulded handle is at once delicate and strong, projecting itself on to the back of the mirror to extend its support. As with most ancient mirrors,

however, it is the decoration of the backs which is their chief beauty. The pattern is at first sight symmetrical, though it swirls with the anchored freedom of an aquatic plant dancing in the current. In two of the finest mirrors, that from Birdlip in the Gloucester Museum and the Desborough mirror in the British Museum, symmetry seems to be

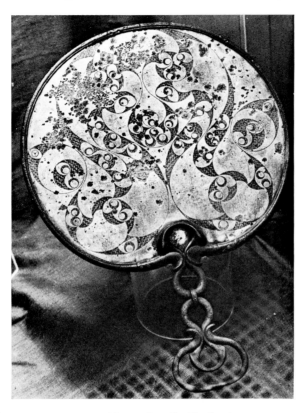

Plate 46 BRONZE MIRROR with cast handle. England
—Desborough, Northants: 1st century B.C. Length 35cm.
British Museum, London, by courtesy of the Trustees

faultless, but in fact there are subtle deviations and in the case of the Birdlip mirror measurement shows the 'central' axis to be anything but central. Others are frankly asymmetrical, for example the Cornish piece from Trelan Bahow in the British Museum and another of unknown provenance at Liverpool. In Celtic decoration, as Dr Henry says, 'equality is generally replaced by equivalence'.[1] She compares this 'equivalent' approach to magical taboos binding the actions of heroes in the sagas. Not that there is any suggestion of imposed taboos so far as these designs are concerned, but undoubtedly there is built into the Celtic character an aversion to the obvious and to monotonous repetition, and it is not impossible that at one time this may have crystallised as some system of

[1] Henry, ibid., p. 199.

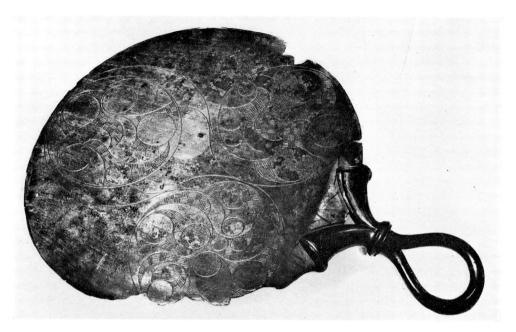

Plate 47 BRONZE MIRROR with cast handle. Southern England: 1st century B.C.
Length 22.4cm.
City Museums, Liverpool (Mayer Collection)

spells. Again we are back in a Tolkien world. When the rational thinking of Roman civilisation invades it, belief in the things of this world are killed or driven into the west. If Celtic art is the stuff of dreams, and the dreams are long forgotten, it has bequeathed its essential elements to the Romantic art of the west. Fox drew attention to possible Roman influence in these mirrors of early in the first century, suggesting Augustan antecedents and comparing the mirror-backs with the floral scrolls on the *Ara Pacis Augustae* in Rome.[1] That the craftsmen had seen Roman models may well be true. However, the imagery of the Celtic mirrors is drawn from the stores of another race, and Fox himself in describing the technique of the 'Mayer' mirror at Liverpool remarks on its virtuosity, the finished, perfected design being a mere intensification of the first, spontaneous sketch. More than any other objects, the mirrors illustrate the Celt's power to express himself as brilliantly in two-dimensional as in plastic forms. Indeed, he made the flat surface of the metal live as perhaps no other artist has ever done by reinforcing his original, basic pattern of lovely, spontaneous, incised forms by infillings of textured surface like basketry done with the chaser, the effect of which is to change the pattern completely according to the angle of light.

The high achievement of the insular schools must be attributed in part at least to remoteness from the sources of classical influence, but at the same time the influx of powerful Belgic and other tribes, with strong identity and traditions and perhaps considerable wealth, would stimulate the right sort of perceptive patronage. Where the south-

[1] Fox, ibid., p. 94.

88

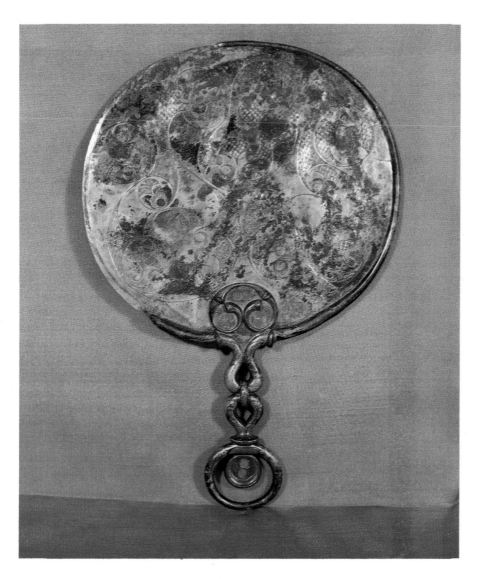

Plate III BRONZE MIRROR, with enamel. England—Birdlip, Gloucestershire:
early 1st century A.D. Length 38·7cm.
City Museum and Art Gallery, Gloucester

Fig. 26
TUROE STONE
Déchelette,
Manuel d'Archéologie

western school flourished there would be relatively settled communities based on an agricultural economy, and here undoubtedly Roman influence built up; the peoples who pushed out into Wales, Ireland and Scotland were able to preserve the La Tène traditions more or less intact. In particular the Irish school, if one may call it that, protected by the sea, survived for centuries and laid the foundations for the era to be considered in the next chapter, working in a tradition long forgotten on the continent. Consider, for example, the small but significant group of stone carvings—they cannot be called sculptures—of which the best-known is the Turoe stone, in Co. Galway. Here we have a monument which is covered with 'protective designs', in Dr Henry's words.[1] It may have been

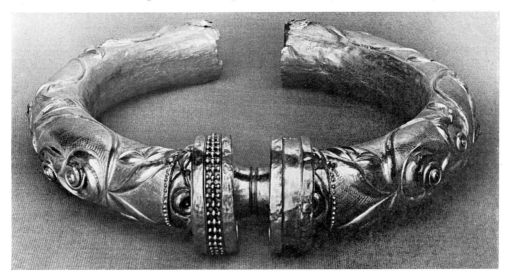

Plate 48 TUBULAR COLLAR, gold. Ireland—Broighter, Co. Derry:
2nd century B.C. Greatest diameter 19cm.
National Museum of Ireland, Dublin

[1] Henry, ibid., p. 188.

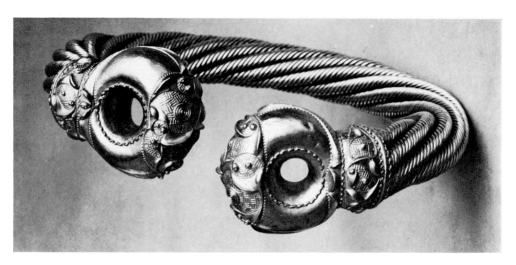

Plate 49 TORC WITH RING TERMINALS, gold. England—Snettisham, Norfolk.
2nd half 1st century B.C. Diameter 20cm.
British Museum, London, by courtesy of the Trustees

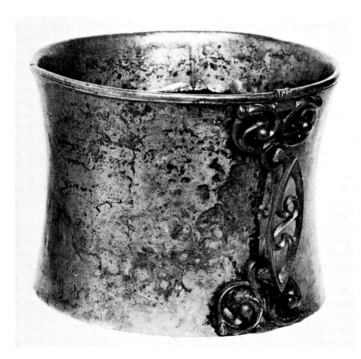

Plate 50 TANKARD, wood with bronze mounts. Wales
—Trawsfynydd, Merioneth: 1st century A.D.
Height 14.2cm.
City Museums, Liverpool

90

looked upon as phallic, certainly as possessing special powers. Its La Tène style is instantly recognisable, even suggesting *repoussé* metal work. It recalls the Pfalzfeld stone, and the Kermaria stone from Brittany at St Germain, which may point to a direct Gaulish incursion to Ireland. Other stones with similar type of decoration are at Castlestrange, Co. Roscommon, and one from Mullaghmast, Co. Kildare, in the National Museum in Dublin. But in Ireland also metalwork seems to have been the principal medium for the artist. The gold mines of the Wicklow Mountains were still producing the metal from which the ornaments of prehistoric times were made, and maybe the source of the metal of the Clonmacnoise torc in the National Museum, though the inspiration, as with the Turoe stone, is Gaulish. The gold collar from Broighter, Co. Derry, also in the National Museum, is another splendid piece in pure Plastic style, although the relationship here is clearly with the electrum torc from Snettisham in Norfolk and other British pieces of about the first century B.C. As to surface decoration, there are scabbards from Lisnacroghera, in both the British and the Ulster Museums, which excel the Bugthorpe scabbard, or at least have incised patterns which are better preserved, and in Edinburgh there is the Mortonhall scabbard with subtly contrasting alloys. The perfection of all these pieces is bewildering, perfection in the sense that in them crystallises, almost suddenly, as if something in the air of the islands precipitated it, the slow emergence of continental La Tène art. Many of the most perfect things come from places which we still think of as on the very outer fringes of the sophisticated world. From Trawsfynydd, Merioneth, comes the bronze tankard handle now in the Liverpool Museum, a virile concept based on four triskeles applied to a simple domestic vessel; and another fine piece embodying the same motif is the shield-boss from the Llyn Cerrig Bach hoard, perhaps a century earlier in date than the tankard, in the National Museum of Wales. The keynote of these four roundels, as Fox wrote, is a balance temporary and precarious, therefore exciting.[1] The Llyn Cerrig find is exceptionally rich in quality, and even if much of the material originated further east it shows that Anglesey, a druidic centre, was familiar with the finest work.

A number of superb La Tène pieces have been found in Scotland. There is of course the gold torc terminal from Cairnmuir, Peeblesshire, in the National Museum of Antiquities in Edinburgh, another creation in the Plastic style linking up with Snettisham. There is also in the same museum the fine sword-sheath from Mortonhall referred to above, differing in decoration from the southern and Irish sheaths in that the ornament is concentrated boldly at three points: a reversed swastika at the hilt, a baldric support ring at the centre and a curious but effective chape formed of twin, solid-cast cups with a finial projecting along the sheath. The bronze collar from Lochar Moss, Dumfriesshire (British Museum), illustrates another means of contriving a sense of movement in a running design, the device which Leeds called the broken-back scroll, whereby the eye is jerked this way and that as it follows the design. One group of ornaments from the north which has no parallel is a series of bronze armlets found mainly beyond the Forth

[1] Fox, ibid., pp. 43–44.

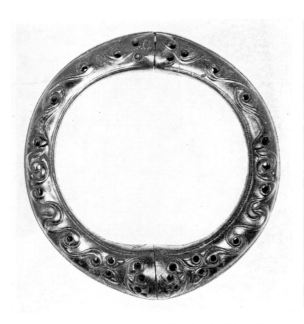

Plate 51 COLLAR, bronze. England—Wraxall,
Somerset: 1st century A.D.
Diameter 17.5cm
City Museum, Bristol

Plate 52 ARMLET, bronze, flawed casting. Scotland—Mains
Auchenbadie, Banffshire: 1st–2nd centuries A.D.
Diameter (max.) 12.8cm.
National Museum of Antiquities of Scotland, Edinbu

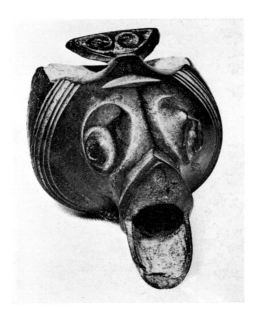

Plate 53
FISH-HEAD SPOUT, cast
bronze, once attached to
wine-straining bowl. Eng-
land—Felmersham-on-Ouse,
Bedfordshire: 1st century A.D.
Length 9.7cm.
Bedford Museum

92

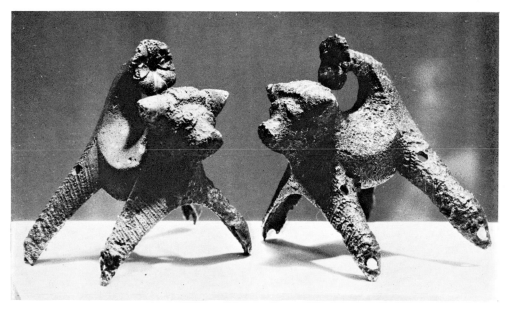

Plate 54 BRONZE MOUNTS in form of bulls. England—Bulbury Camp, Lytchett
Minster, Dorset: probably 1st century A.D. Length 6.4cm.
Dorset County Museum, Dorchester

area,[1] massive, obviously parade pieces, arrogant in their interplay of flanges. There are
several in the National Museum of Antiquities, including an unfinished casting vigorously
conceived, but the finest are those from Drummond Castle and Castle Newe, which have
found their way into the British Museum. Small areas of red and yellow enamel add to
their effectiveness. The enamels, as well as a high proportion of zinc in the metal, suggest
a date after the Roman occupation of the south, but here again we have a vigorous develop-
ment of the La Tène style coming from a fringe area.

Until smothered by the relentless advance of Roman provincialism, the heartland of
the insular culture remained the south-east. The term 'Celtic fringe' is so familiar that it is
difficult to eradicate the association of the Celt exclusively with the remote and mountain-
ous regions to which he penetrated later; however, as much as any other people he pre-
ferred rich, productive land, and the lowlands of the south and east, extending of course
up into Yorkshire, show a greater concentration of rewarding finds than do other parts
of the country. In this region in the first century B.C. the power of the Belgic tribes
established itself. The best artists and craftsmen must have been attracted by prospects
in the area, and this is reflected in such masterpieces as the Battersea shield. The Belgae
were a people with some Teutonic blood, and were a practical people with relatively
advanced agricultural skills—in fact they were very much more than a marauding tribe;
and their rulers, who included Cassivellaunus and later Cunobelinus, in consolidating
the tribes of southern Britain encouraged one of the most distinctive advances in the
development of Celtic art.

[1] Morna Simpson in *Studies in Ancient Europe*, pp. 233–54.

93

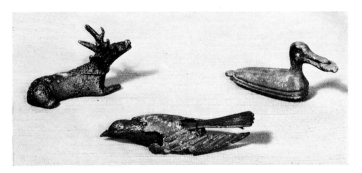

Plate 55 BRONZE ANIMALS. England—Milber Down,
Devonshire: 1st–2nd centuries A.D. Lengths 5.8,
6.2, 7.1cm.
Devon Archaeological Society, Torquay

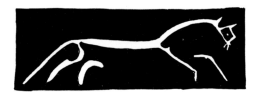

Fig. 27 WHITE HORSE OF UFFINGTON
From photograph

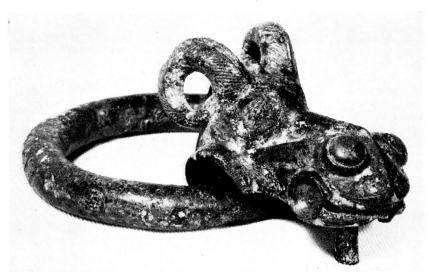

Plate 56 BRONZE TUB HANDLE in form of ram's head. England—
Harpenden, Hertfordshire: perhaps mid-1st century A.D.
Length (head) 7.5cm.
Luton Museum and Art Gallery

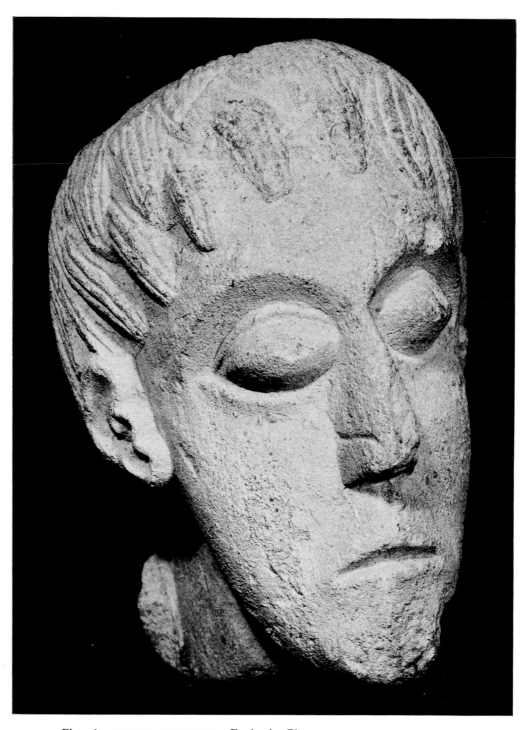

Plate 61 CARVED STONE HEAD. England—Gloucester: 1st century A.D.
Height 75cm.
City Museum, Gloucester

tend to suggest an exotic culture floating, as it were, above the heads of a possibly in-different community. Most of the world's major artistic achievements are responses to the requirements of a privileged minority, even if a relatively large minority as in the case of the Dutch school of painting; and to-day, in spite of lip-service to democracy, when the state has to step in with public money to support such enterprises as opera, orchestras, and even the theatre, one can hardly say the admirable results reflect public taste. Among the Celts there was an additional element of privilege in that the artists and craftsmen themselves had special social status. However, Celtic society was not urban and was closely knit, probably sharing joys and sorrows as more complex communities could not do. In Britain this may have been especially true. At least until after the Roman invasion, chieftains had not the same ready supply as in Gaul of elegant classical wares to make them independent of local purveyors for their best 'services'. As to 'peasant art', Fox devotes a short chapter to this in *Pattern and Purpose*. So far as pottery is concerned, the bulk of finds are plain, though the La Tène style must have been thoroughly under-stood by some local craftsmen, even if their essays were not ambitious. The finds at Aylesford, Glastonbury and Meave are decorated with beautiful and often quite complex curvilinear patterns. The assurance and grace of these is the more remarkable because the patterns were not painted as in Gaul, but impressed or incised. The sense of movement and the delicate equilibrium typical of metalwork are often achieved by the potters. Some of the S-scrolls on pottery from Glastonbury or Hunsford (Northampton) are too lively,

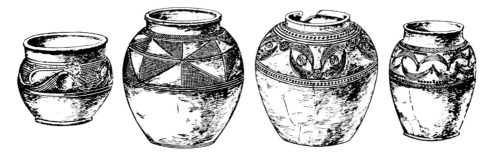

Fig. 28 POTTERY, Glastonbury
British Museum Guide: Iron Age

too exuberant to be mere transferred decoration, although no doubt the potters had seen such work on Gaulish pots. Again and again such pots share in full the spirit of the princely arts, if executed in humble materials. The pots and urns on which these patterns are done are hand-made on some sort of turntable, but the Belgic tribes introduced more sophisti-cated methods and shapes, substituting for the simple, ovate outlines more elegant ones reflecting classical models. Glazing was not understood. (Even in the classical world true glazing was exceptional.) Glass, however, was employed for personal ornaments such as beads, and the technique of polychrome manufacture, even of a sort of *millefiori*

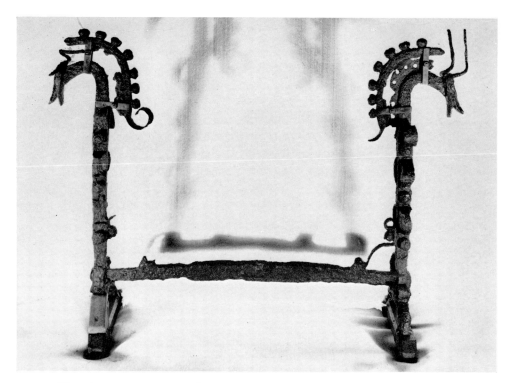

Plate 62 IRON FIREDOG. Wales—Capel Garmon, Denbighshire: early
1st century A.D. Height 75cm.
National Museum of Wales, Cardiff (loan)

process, was understood if never attempted on an ambitious scale. The only other medium
of art which might be included in this peasant category is ironwork, if we assume that
much of it was made by the equivalent of the village blacksmith. In so far as it called for
techniques and skills very different from those employed for the finer metalwork, the
ironwork may well have come from the village forge. Iron, of course, perishes and there
must have been far more of it than we know. Ironwork survives mainly in the form of
great iron fire-dogs, usually buried with the dead to insure the success of their feasting
in the other world. Most of these pieces are simple, consisting of a cross-piece with two
uprights, the terminals of which are wrought, and wrought with considerable skill, in
the shape of ox-heads with the horns terminating in lobes. Quite the most elaborate of
those fire-dogs is the one from Capel Garmon (Denbighshire) in the National Museum of
Wales. The ox-head terminals are fitted with elaborate crests, and undulating ribbons
of iron are riveted to the uprights. It must indeed have been a chieftain's piece. Pairs of
fire-dogs have been found in some cases, and for some reason it has been deduced that
this signified twin fires; but surely, as no wall chimney-place is involved, the pair of dogs
would be placed centrally with great logs thrown across the two, a magnificent focus for
a night of roisterous hospitality. These insular fire-dogs differ from their continental

101

prototypes generally in the height of the upright members, but the animal-headed terminals occur both in Gaul and in Italy.[1]

The effect of the Roman conquest on the arts, in the area most immediately under Roman rule, differed only in degree from the effect in Gaul. Mediterranean civilisation did not perhaps overawe by its monuments and public works as it had done in southern Gaul; but the Romans for administrative reasons encouraged urban development with all its amenities, and although the native aristocracy retained its country estates, its liking for the exotic and for good living would make it seek all the new 'improvements' available, from drainage and central heating to mosaic floors, imported pottery and portrait busts. However, when it comes to emulation, the language of art can be more difficult to learn than a foreign tongue. British artists imitated outward forms of the background and meaning of which they were largely ignorant. Most of their attempts are crude. If occasionally there is a compromise with some merit between native tradition and Roman realism, as for example the head at Gloucester already noted, the virtue of the piece lies not in a successful attempt at facial modelling but in the haunting feeling of the ancient *tête coupée* which clings to it. Identification of Roman deities with Celtic produced a wide variety of cult figures in stone the iconography of which has been explored by Dr Ross.[2] Aesthetically a large majority are degenerate: clumsily-conceived figures of Mars

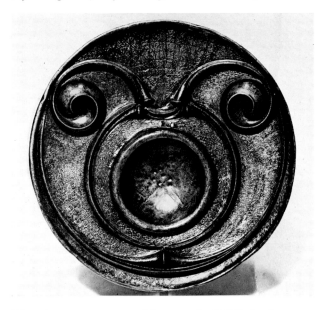

Plate 63 BRONZE DISC with *repoussé* relief. Ireland—
locality unknown: 1st–2nd centuries A.D.
Diameter 27.3cm.
British Museum, London, by courtesy of the Trustees

[1] Déchelette, ibid., pp. 1400–1401.
[2] Ross, ibid., chapters III–V.

such as those at Gloucester, the naïve representations of Mercury in the same place, or attempted translations into the new idiom of Celtic deities such as Cernunnos or Epona, or the mysterious but more accomplished trio of hooded figures from Housesteads, at Newcastle. Southern Britain at least had become thoroughly provincialised.

That element of poetic abstraction so vital to Celtic art cannot successfully co-exist in one work with classical realism, however ideal. When they take human form Oberon and Titania lose their elfish magic. Symbolism is second-nature to the Celt. His visions are woven out of symbols, symbols of the greatest elegance, marvellous in execution. This abstract art of the Celt attained its peak in the British islands in what is commonly called the Late La Tène style, and only where the legions did not penetrate did the style survive in sufficient strength to go on developing. Understanding and sympathy for this traditional style was not completely dead in the provincial community, because Roman power was concentrated at the perimeter defences and in the towns, while the Celtic aristocracy which adopted Roman ways probably exerted little influence beyond the boundaries of its estates. The real ascendancy of the manor and its lord had to wait until the Middle Ages. But it was above all in Ireland, where the Romans never set foot, that the inheritance and the aptitude for devising means to give elegant expression to it were able to lie dormant until a new opportunity arose. Among such refuges one should not forget Brittany, Armorica, where many Britons fled under fear of the Saxon threat. The influence of the refugees, however, seems to have been more linguistic than artistic. The Saxon threat did rouse in some of the British chieftains the old spirit of Boudicca and Caratacus, among them the man who has come down to us as the personification of chivalry, Arthur; but south Britain proved too vulnerable in the end, and only beyond the wild Border hills and the western sea could the ancient culture survive at all and with it, precariously, the new faith that was to bring about its renaissance.

VI

The Christian Era (1)
The Early Church

We speak of the Dark Age that followed the Roman withdrawal from Britain. By contrast it was dark, but as our eyes become accustomed to the contrast this becomes less dramatic. Massive as were the raids of the Saxons, they did not turn all Britain into a blackened desert. Disintegration of the old Roman provincial way of life seems to have been gradual, and new villas and temples were still erected here and there, repairs carried out to the old, if with decreasing skill. Gradually defensive walls begin to be introduced, reflecting the unease of the builders. The urban culture brought by the Romans had probably never greatly influenced more than the ruling and official classes. At the end of the last chapter it was implied that old crafts and traditions may have remained alive outside the immediate influence of the towns and great villas. On the other hand, that emotional tension and sense of challenge which had fostered the warrior art of past times had long been missing, and the climate of decaying colonialism would do nothing to revive it. There was not so long ago a belief that Celtic art died with the Roman conquest; but even if this had not been disproved by subsequent discoveries and research the achievements of the 'revival', and perhaps equally the evidence of Irish literature, show beyond a doubt that it was far from dead.

In provincial Britain the official Christian faith of the Empire, organised rather on civil service lines, inspired artists and craftsmen to nothing more stirring than the furnishing of private chapels in the greater villas. This colonial orthodoxy can have done nothing to stir up the deep dreams of the Celtic mind. But already by the third century in the Christian world a reaction against orthodoxy had set in. Like the foundation of the faith itself, it came about in what we now call the Near East. The asceticism of the Desert Fathers refocused thought on the profounder spiritual issues. News of these solitaries and their meditations was eagerly listened to in the west, and in Gaul they were imitated by hermits who for desert wastes substituted lonely islands, and these men, forswearing wealth and personal interest and worldly power, probed again to the core of the original beliefs. Here at last was another rallying-point for disciples, a stimulus for a new wave of fervour. In its turning away from materialism to the contemplation of mysteries it had a special appeal for the Celt. The eremitical movement spread to Britain, and in particular

to the remoter coasts of Scotland and Ireland which, hostile to husbandry and comfortable living, yet knowing days and nights of unearthly beauty, paralleled the desert in their capacity to foster the contemplative life.

For the first time in their history it begins to be possible to glean from their own written records impressions of the culture of a Celtic people, though the records were made at a later date from traditions handed down. We are told, for example,[1] that St Patrick had craftsmen in his company when he went as missionary to Ireland in 432, craftsmen trained in 'various arts'. He and his companions are said to have taken with them altars, bells and chalices of forms already traditional in the west; but those missionaries had the wisdom at least to appear to respect the holy places and practices of people they went to, and as time went by not only were the new beliefs probably grafted successfully on to the old; the symbols of the new beliefs became vehicles for the surviving insular tradition in art too. It is possible new motifs had already been introduced from southern Europe before Patrick's time, as indeed there may have been a few Christians; but not until the Church became established firmly and the craftsmen in her service turned actually to the old secular art did a new phase in Celtic art begin to come about.

At first this is hard to trace. Nowhere was the Celt ever a builder of great monuments, and as to portable works the Christian, unlike the pagan, did not bury with his dead their earthly or spiritual goods, thus saving them from the raiders and pirates who infested the waters and coastal regions of the west after the fall of the Empire. There were certainly churches, although it is improbable that anything worthy of the name of church architecture existed. Wood appears to have been the native building material. The *Mos Scottorum* of Bede refers to timber construction of a type which Baldwin Brown considered common to Celts and Saxons,[2] but there seems to be no evidence of its embellishment though Strzygowski cites Bishop Venantius Fortunatus[3] in support of elaborate ornament of timber buildings in the Rhineland in the sixth century. Among the Celts the druidical tradition of the sacred grove probably persisted, and Patrick may not have found many temples to consecrate as churches. The few Christians who may have preceded him in Ireland, Gaulish disciples of St Martin of Tours, were a chorites and no doubt lived in caves or huts; but Patrick, perhaps sent to combat the Pelagian heresy would need some semblance of orthodox surroundings for his rites. He seems to have erected at least one considerable church. As a rule, however, he and those who followed him adopted local methods of building, and even converted raths (forts) given them by chieftains. As to surviving stone buildings—the native wooden structures obviously have perished—the most elaborate settlement is the celebrated group of beehive cells and oratories on the rock of Skellig Michael, off the Kerry coast. There were, however, many such monkish colonies in inaccessible places in Irish and Scottish waters, and the

[1] Henry, ibid., p. 17.
[2] G. Baldwin Brown, *The Arts in Early England,* Vol. II, *Dark Age Britain,* London, 1956, p. 37.
[3] Strzygowski, ibid., p. 84.

crude nature of the stonework of those huts is expressive of nothing but dedication to asceticism. Indeed sometimes, as Dr Henry suggests in one place, there may have been no church for the worshippers, but only an open enclosure, with a wooden altar propped against a central slab marking the grave of the saint founder.[1]

This slab or monolith is the starting-point of the long series of Christian Celtic stone monuments. In its beginning it is a bare symbol of the strange faith which in a stormy world had been cast up like flotsam on northern shores. Typically, the slab bears a cross. Sacred stones were of course features of the pagan Celtic cult, and the Pfalzfeld and Turoe stones have been described. St Patrick is recorded as carving crosses on stones associated with pagan worship. The earliest cross-marked stones are what one can only call functional, with no attempt at elaboration and no hint of concession to the artistic traditions of the native community. There may be nothing more than a plain, incised cross, as on the stones of St Patrick's Chair at Kirk Marown on the Isle of Man, or a circled cross with brief Latin inscription together with an inscription in ogham, the earliest Irish form of writing, as the Castell Dwyran stone in Carmarthenshire, or a slightly more elegant cross as on the pillars at Kirkmadrine in Wigtownshire. Ireland has many such monuments, and Cornwall possesses them also. For the Celt, abstract symbolism has a special appeal. In Ireland the Christian symbol rapidly found roots and flowered into something quite unlike what it became elsewhere in Christendom. So far from dead was the La Tène tradition in Irish soil that almost at once it began to nourish the cross, causing it to sprout tendrils at its terminals, as on the stones at Caherlehillan and Kilshannig (Kerry), or to become a swastika as at Cloon Lough in the same county. They are a new flowering from an ancient root, those stones. That they were sometimes at least planted in soil sanctified by the pagan cult may even be reflected in names, and the late Dr Douglas Simpson found a Scottish example of this in the St Ninian site in Glenurquhart, overlooked by Creag Neimidh, the rock of the sanctuary,[2] perpetuating the ancient Celtic *nemeton*, or sacred grove. If the stones are rough, the incised outlines of cross and decoration are sure in concept and precise in execution, so that as Dr Henry says the contrast between rough background and elegant symbol makes such objects as the Reask pillar or the big slab of Inishkea unforgettable at first encounter.[3] They date from the sixth and seventh centuries. By the end of this period the craftsman has begun to show a wish to shape the stone itself instead of merely to draw a cross upon it.

Metalwork was the principal medium for artistic expression at this as at other times among the Celtic peoples, and the achievements of the eighth century themselves require a build-up of technical skills, at least in the preceding period. The most accomplished work of the time is perhaps the group of so-called hanging-bowls. These bowls have given rise to much controversy. They derive from a type of vessel used in Roman times, and possibly in the seventh century some began to be adapted for Church use. How wide-

[1] Henry, ibid., p. 27.
[2] Douglas Simpson, *The Celtic Church in Scotland*, Aberdeen, 1935, p. 56.
[3] Henry, ibid., p. 33.

spread they were is difficult to assess, and only recently has evidence of Irish bowls come to light, though many of the English examples may be Irish in origin. The Sutton Hoo treasure included three such bowls, one contained in a Coptic bowl. Dr Henry suggests[1] they may be associated with the mission of the Irish monk Fursey to East Anglia around 636, at the invitation of Sigebert, although Elizabeth Fowler qualifies this view.[2] The bowl associated with the Coptic piece has three rings for suspension by chains, and the decoration consists of plaques, square and circular, with exquisite patterns executed in *champlevé* enamel, running spirals of much elegance, together with *millefiori*. This bowl has evidently been repaired by a Saxon craftsman, and Bruce-Mitford has pointed out[3] that some of the Saxon work in the hoard has been influenced by these Celtic enamels. Bowls of this kind were thought to have been lamps, but Fowler has shown this to be unlikely and has put forward the theory that they were suspended in tripods, perhaps for ablutionary purposes.[4] It may have been largely through vessels of this sort that Celtic craftsmen developed that marvellous aptitude for enamel-work to be described in the next chapter. The delicate curves, the spontaneity of Celtic line-drawing must have been hard to contrive in this technique. The escutcheons of the big Sutton Hoo bowl have running scrolls of considerable intricacy which swirl, each of them, about the interlocked

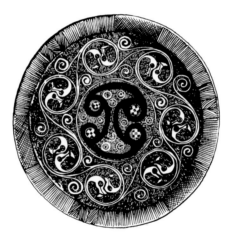

Fig. 29
SUTTON HOO BOWL
ESCUTCHEON
After photograph

heads of a pair of minute monsters, and the unerring flow of these eddies is unrestricted by the enamels into which they are frozen. The same apparent spontaneity can be seen on many little pieces, fragments of other bowls, latchets and penannular brooches. The lyric beauty of La Tène metalwork is here finding a new outlet, miniaturised and with new and brilliant colours, producing an art much more expressive than the work of the Saxon jewellers who, thinking in terms of rigid settings and cloisons, had so much in-

[1] In *Dark Age Britain*, ed. D. B. Harden, p. 82.
[2] In *Studies in Ancient Europe*, ed. J. M. Coles and D. D. A. Simpson, 1968, p. 299.
[3] R. L. S. Bruce-Mitford, *The Sutton Hoo Ship Burial*, London, 1968, p. 74.
[4] Fowler, ibid., p. 288.

fluence on the illuminators of the Book of Durrow. Ireland, indeed, between the fifth and seventh centuries developed a knowledge of this branch of glass techniques that compares well with any similar achievement in the first millennium of our era. The beginnings of it were probably much earlier, for great numbers of Roman imports have been found in Ireland, where they were copied and modified to suit Irish tastes. Workshops of glass-makers have been excavated at Garranes in the south and in the crannog of Lagore, both of which provide some evidence of the making of enamels and *millefiori*.

This marriage of multi-coloured enamels and miniature metalworking is a vital part of Christian Celtic art. Its application to the hanging-bowls does not quite seem to be part of the bowls as the sophisticated work that succeeded it was part of the chalices and other objects of a slightly later time. In its earlier stage it is indeed a jeweller's art, enamel taking the place of jewels, and it was lavished on vast numbers of brooches and pins and other small articles. The simplest objects are the hand-pins, which evolved

Fig. 30 HAND-PIN, Norrie's Law
After Romilly Allen, *Early Christian Monuments*

from short pins with ring heads embellished with beads, dating from the third or fourth centuries. The pin grew much longer and more substantial, the ring developed into a hemisphere completed by three bead-like members, and this head was ornamented with enamel and *millefiori* similar to those on the plaques and medallions of hanging-bowls. On the tiny surface of the hemisphere were worked also the loveliest running scrolls, swirling within their close confines as freely as anything in the La Tène tradition. As the two types of treatment appear together on the Sutton Hoo hanging-bowl one must assume they ran contemporaneously, although the scroll pins are much more sophisticated aesthetically. They are dated variously to the sixth or seventh century. The greater number come from Ireland, but there are some perfect examples in the National Museum of Antiquities in Edinburgh. Like all these small objects the hand-pins have a Roman origin, and the same is true of the pennular brooches which, always under modification, found their way from the mainland of Britain to Ireland. Penannular brooches date from pagan times, but the basic form of the great brooches of the eighth and later centuries must have evolved in the sixth and seventh with a simple flattening out of part of the ring, as illustrated by the Norrie's Law brooch, and the severing of the ring by cutting a channel through the centre of the flattened area, as in the Ballinderry brooch in Dublin or another in Dublin with symmetrical scrolls on the flat area.

The boldest manifestations of the survival of the La Tène spirit are shown by the few surviving larger pieces of metal-work. One of the best-known of these is the so-called 'Petrie Crown' in the National Museum, Dublin. The present form of this object has been disputed, but the pieces may belong to a votive crown for hanging in a church.[1]

[1] Henry, *Irish Art*, p. 41.

Fig. 31
THE PETRIE CROWN
From photograph

The crown is wrought in the spirit of the Torrs pony-cap in Edinburgh, and it is the spirit of the Llyn Cerrig plaque and the Wandsworth shield-boss and many other objects of eight or nine centuries earlier. The artist who decorated the 'crown' did his work with every bit as much conviction and assurance as his predecessors. There is no breath of the new beliefs here, no hint of the new influences. With pagan delight the spirals even sprout leaf-buds as on the Torrs pony-cap they sprout birds' heads. In secular art in the sixth and seventh centuries this spirit must have been widespread, and it may do something to explain the exuberance and vitality of the coming age. The same conviction and power of execution can be seen in the bronze disc from Ireland in the British Museum and the trumpet from Lough-na-Shade at Armagh, or again the bronze disc from the Bann at Belfast. This is metal-working worthy of the bronze-smiths of the Iron Age!

A renaissance, however, is much more than a revival. The Celtic genius had never been able to exist in isolation, and the trickle of contacts with the outside world during the two centuries or so after St Patrick's coming could not have sustained it. The bridging of the gulf between Ireland and Europe provided just the sort of conditions it needed. Augustine's mission to England in 597 brought about a confrontation which reached its climax with the defeat of the Celtic Church at the Synod of Whitby in 664. One is apt to smile to-day at the 'errors' of the Columbans, such as the date of Easter and the mode of tonsure, and to regard the defeat as just another Roman 'take-over bid'; but perhaps spiritually, and certainly in their art, insularity was not altogether a good thing for the Irish, and not all the saints in Ireland could do for the artists and craftsmen what renewed contact with the old civilisation of the south could do. As Dr Henry says, 'the doors of the world were flung open before them'.[1] Already in the sixth century Irish missionaries had re-lit the torch of Christianity throughout western Europe. In 563 St Columba had established himself on Iona, perhaps in part in a spirit of militancy, as Dr Douglas Simpson believed, to counter the Pictish threat to the Scots (Irish) of Dalriada. From Iona and from other foundations in Ireland, supreme among them Bangor, Columba and other 'pilgrims' carried their faith to many parts of what was to be Scotland and into pagan Northumbria, to Lindisfarne; and from Bangor too only a little later in

[1] Henry, ibid., p. 45.

the century they went into Gaul, founding the monastery of Luxeuil, and into Switzerland and Italy, where they established religious houses at St Gall and Bobbio. To all those places they took their crafts, and their art, in the service of their faith. Now in the seventh century, with the doors open, the pilgrims became missions in strength, and when they returned they came laden with sacred works of art and new techniques, their minds pondering the splendours of Byzantium and the East, and with them were pilgrims from Gaul, Italy, even Egypt, attracted in growing numbers by the spiritual repute of the Irish holy places.

The first impact of this foreign influence upon the Celtic tradition seems more of a threat than an encouragement. I have said earlier in this chapter that the cross took root in Irish soil, though for a time there was a vigorous invasion of alien forms. The Maltese cross, contrived from compass-drawn segments of a circle, appears on stone monuments, as one at Whithorn (Galloway) and another at Inishkea North (Mayo), and Dr Henry has seen in this a possible effect of the Roman success at Whitby, as the form has Gaulish antecedents.[1] Another exotic motif is the so-called 'marigold', sometimes resembling a multi-armed Maltese cross, which occurs at Carndonagh (Donegal), Maughold on the Isle of Man, and Ellary in Argyll, among other places. Clapham associated this with Visigothic art,[2] and there are many examples in southern France and Spain. The Carndonagh cross also exhibits another new element in decoration, and one which was to become a striking feature of Christian Celtic art; the interlaced ribbon pattern.

Fig. 32 SLAB, INISHKEA
NORTH
After Henry, *Irish Art*

Fig. 33 CARNDONAGH CROSS
After Henry, *Irish Art*

[1] Ibid., p. 51.
[2] A. W. Clapham, 'Notes on the Origins of Hiberno-Saxon Art', *Antiquity*, Vol. VIII, 1934.

This idea would seem to have been borrowed from Coptic Egypt, and borrowed direct, not by way of England and Germany. They got their interlaced ribbon work from the same source, but in England at least there is a dominant classicism, as can be seen in such great monuments of the Northumbrian school as the crosses of Ruthwell and Bewcastle, which derived their motifs through the Roman mission. As Nils Åberg stresses, the Irish monuments, and of course the Scottish stones done under Irish influence, belong to a completely different tradition, opposed to the classical, perhaps not even influenced by Northumbria.[1] In the beautiful sculptured cross slab at Fahan Mura (Donegal) the interlacing can be seen developing a quite new insular character. It developed also in Dalriada, but, significantly, not further south, and in Wales there was a lag of something like two centuries before it appeared. The manuscripts, with which I will deal presently, were of course its principal vehicle. However, of all those importations, most alien of all to the Celtic past is the use of the human figure. It is unthinkable that Ireland, exposed to the full impact of Christian iconography, could have continued to portray only stylised crosses and resisted the urge to render the Crucifixion; yet the antipathy to

Fig. 34 FAHAN MURA SLAB
After Henry, *Irish Art*

Fig. 35 DUVILLAUN SLAB
After Henry, *Irish Art*

portrayal of the divine presence in human form, which is in general part of the pagan Celtic heritage, even if Christian teaching had largely overcome it, made it very difficult for the artist to work with any assurance. There are a number of stones carved with Crucifixion scenes. One which illustrates well the artist's problem is a slab on the island of Duvillaun, Co. Mayo, where the naked body of Christ is accommodated almost precisely to the outlines of the cross as if clinging to them as guide-lines. The hands are little more than fins, the legs, modelled in profile, are much too short, and body and thighs

[1] Nils Åberg, *The Occident and the Orient in the Art of the Seventh Century—the British Isles*, Stockholm, 1943, p. 36.

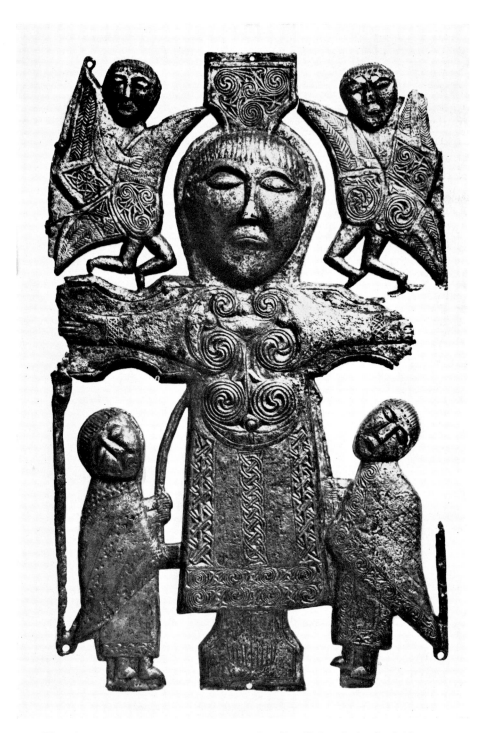

Plate 64 GILT BRONZE PLAQUE representing Crucifixion. Ireland—Athlone,
Co. Westmeath: 8th century A.D. Length 20.8 cm.
National Museum of Ireland, Dublin

are connected by whorls or 'joint-spirals' reminiscent of a prehistoric tradition developed by the Celts. The required sense of awe may have inhibited the artist, for he is more at ease with the small figures of the soldiers. The bronze-smith who made the gilt plaque from Athlone, Westmeath, in the Dublin Museum, had less hesitation in seeking inspiration in ancient tradition, for the head of Christ almost sets one thinking of Roquepertuse, and the robe in which He is clothed is merely a compartment to contain a typical abstract pattern. This confrontation of the Irish artist with the problem of depicting not merely man, but the Son of Man, is one of the most interesting passages in the history of Celtic art, and through the centuries following I think it always remained a challenge to him.

For Irish art the most important result of foreign influence around this time is the appearance of manuscript illumination. Gospel books must have been produced in Ireland from the fifth century, and Irish monks evolved a script of their own known as 'Celtic half-uncial'. But wherever there were great foundations there must have been a call for gospel books worthy of their dignity, especially for a priesthood so sensitive to the power of symbolism. In the late sixth-century Cathach of St Columba, in the Library of the Royal Irish Academy in Dublin, initial letters have a decorative swirl that is vaguely insular and are contoured with red dots in the manner of Coptic manuscripts, a feature

Fig. 36 INITIAL, CATHACH OF COLUMBA
De Paor, *Ireland*

that also occurs in one of the early Bobbio manuscripts. However, there is little obvious lead-up to the appearance in the second half of the seventh century of the Book of Durrow, now preserved in the Library of Trinity College, Dublin. The neat script seems to point to the book's having been written in Northumbria, probably at Lindisfarne, although Dr Henry sees no reason why it should not have been produced in Ireland

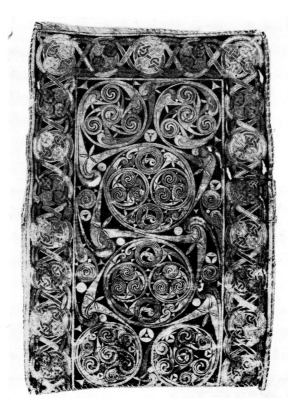

Fig. 37 EVANGELIST SYMBOL,
Book of Durrow
After Henry, *Irish Art*

Plate 65
BOOK OF DURROW, page of
ornament (folio 3v). England
—Northumbria: second half
7th century A.D. 14.2 × 16.7cm.
*Library of Trinity College,
Dublin*

itself.[1] The decoration certainly was done by an Irish illuminator, although he had not yet absorbed and made part of his repertory the various foreign elements which used to make writers give it to the 'Hiberno-Saxon' school. On the other hand, Anglo-Saxon influence was only now beginning to be felt in Ireland. That the intertwining and inter-biting animals are Saxon in inspiration is not in doubt, and they have not yet become Celticised as happens in the great manuscripts of the following century. In some cases, for example the Evangelist pages where the Durrow lion symbol is clearly modelled on a piece of Saxon jewellery, *cloisons* and all, the origin is very clear; yet even here there is a transition from naturalism to symbolism, with the animals alone on their pages, unaccompanied by their Evangelists; and in the case of the lion we may find ourselves tracing back full-circle to an origin at least semi-Celtic, as will appear presently when we consider the Picts. Some other foreign features in the book are already in process of adaptation to the Irish idiom. The notion of covering a page with decoration comes from the Near East, but not the fastidious way in which it is done, nor the balance and the contrast between intricate detail and carefully reserved spaces to rest the eye. The initial double cross, and of course the interlacing, are Coptic features, and the colours selected may also be so, but another look at the sculptured crosses already referred to, such as Carndonagh, shows a joint advance towards another new decorative mystique, a renewal of the ancient

[1] Henry, ibid., p. 45.

114

methods of communication through symbols, meaning as much as or more than the written word itself, which is something quite foreign to the Coptic prototypes. In the manuscripts even more than on the monuments or the metalwork can be recognised the emergence of an enthralling new style. As metalwork was the appropriate medium for the supreme art of the La Tène warrior society, so the vellum page of the Gospel book challenged the artist whose patron had set himself to evangelise the world.

It is essential at this point to consider the relationship between the Irish school and the Picts. In one sense the Picts are yet another foreign influence, but in part at least they were Celts, a fusion between Celtic invaders and a Bronze-Age people, and they spoke a Brythonic variety of Celtic.[1] Their art is unique, and yet it is inseparably linked with neighbours to the south and with those to the west. Most of it is in the form of stone carvings. Romilly Allen first grouped the stones in three classes for dating purposes, and those which he placed in Class I are ascribed to the period between A.D. 500 and 700 and therefore fall within the scope of the present chapter.

Class I stones are usually boulders on which are incised in outline two types of symbol: abstract devices and animals. Almost invariably the cutting of the stone is done with sureness and precision, the execution is elegant. Some of the cutting is wedge-sectioned as if done with a chisel, some is channelled as by a gouge, some chipped out, though the line is always smooth and even delicate. Obviously these are not the first attempts by the Picts in this difficult medium, and their level of accomplishment implies a society in which the artist was esteemed and encouraged.

The abstract devices or symbols proper have baffled archaeologists for generations and still do, although various interpretations have been attempted. Commoner devices include the spectacles and Z-rod, the crescent with V-rod, the mirror and comb, the serpent and Z-rod. All are rigidly stylised even in their details, which suggests some totemistic or religious purpose. The precision of execution is accomplished in part by the use of compass and straight-edge, but upon the basic figures is imposed a variety of in-filled patterns and what might be called 'embroidery', all done with deftness and in fault-less taste; the patterns, as on the South Ronaldsay stone, in the National Museum of Antiquities, are often put together from very Celtic-looking scrolls. Sometimes the symbols have a casual or even decadent look, and as these appear on later stones the decadence may point to some change in the habits or beliefs of the people, conceivably even a retreat of totemistic magical practices in the face of advancing Christianity, although I hasten to say this is mere guess work. Another symbol which, though abstract, appears to have some connection with the natural world is the 'Pictish Beast', a creature apparently wholly fanciful though it is drawn with the same sort of living outline and whorled musculature as the representations of real animals which we shall consider presently. The beast bears a marked resemblance to the biting beasts of the Book of Durrow and to the odd, articulated dragon on the Sutton Hoo shield, but I will defer comment on this to the following paragraph. First it should be mentioned that the abstract symbols referred to

[1] K. H. Jackson in *The Problem of the Picts*, ed. Wainwright, Edinburgh, 1955, pp. 152–3.

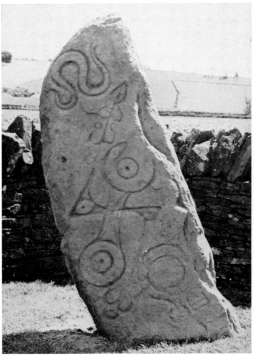

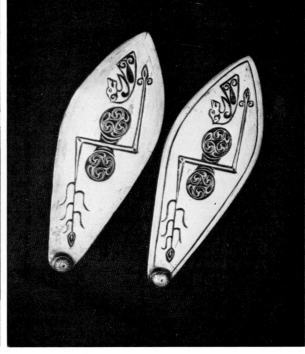

Plate 66 STONE INCISED WITH ABSTRACT SYMBOLS. Scotland—Aberlemno (roadside), Angus: Pictish, 7th century A.D. Height 1.65 m.

Plate 67 SILVER PLAQUES ENGRAVED WITH SYMBOLS. Scotland—Norrie's Law, Fife: Pictish, 7th century A.D. Length 8.9 cm. *National Museum of Antiquities of Scotland, Edinburgh*

above appear also on a group of silver objects found within the Pictish area. One of the two hand-pins of Celtic type from Norrie's Law, Fife, in the National Museum of Antiquities, has the V-rod engraved on the hemispherical head, and from the same hoard is a pair of leaf-shaped plaques with the spectacles and Z-rod, the spectacles infilled with running scrolls, the background emphasised with red enamel. Symbols also appear on the terminal rings of the silver chain from Whitecleugh, Lanarkshire, in the same museum. The engraving on these pieces is delicate and quite superb, suggesting that the output of Pictish silverwork must have been extensive. Chains such as this—there are several—were probably ceremonial badges of office, and it may be significant that in Wales neck-chains, not crowns, were worn by certain kings.

The animal symbols are as challenging as the abstract symbols. They are stylised, in a sense almost stereotyped, yet they sparkle with vitality and give the impression of being only once removed from life sketches. A comparable combination of formalism and impressionism had of course already occurred in far-off prehistoric times, notably in Upper Paleolithic cave art, where marked stylisation does nothing to kill the apparent spontaneity. The conventions of Pictish animal art, however, at once invite comparison

with the animal art of other peoples, especially the continental Celts. The curious whorl-like renderings of musculature or shadow which have been called joint-spirals, elaborating shoulders, haunches and other parts, go back beyond the Celts altogether to Scythian roots; but sometimes the whole treatment of the animals suggests a remarkable flash of race-memory or something of the kind; and I am thinking especially of the boar of Knocknagael, Inverness-shire, which has an astonishing affinity with the animal on the Boar God of Euffigneix at St Germain. If there are good boars on some of the slabs and tablets from the Antonine Wall in the Hunterian Museum, Glasgow, they offer no bridge between the Picts and distant Gaul. There may in fact be little significance in this. Both Gaul and Pict knew what a boar looked like in profile, and the northerner had picked up the trick of the joint-spiral from his Celtic cousins to the south, but somehow the lines of his animal leave one with the suspicion of a closer affinity. On the other hand, theories that the Pict borrowed his imagery from his Anglo-Saxon neighbours, either direct or through manuscripts such as the Book of Durrow, seem often to be untenable. Dr Henderson has done a careful comparison between, for instance, the Durrow lion and the wolf at Ardross in Ross-shire,[1] and although the link is manifest it is too much to believe that the Pictish artist could have had the Durrow lion as his model. One might as well say that Delacroix painted his lions and horses from armorial bearings! The manuscript illuminators were working in a jeweller's idiom, as Dr Hender-

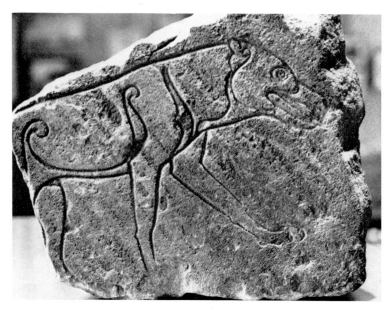

Plate 68 STONE INCISED WITH WOLF. Scotland—Ardross, Easter Ross: Pictish, 7th century A.D. Length 48.3cm
Inverness Museum

[1] Isobel Henderson, *The Picts*, London, 1967, pp. 122–3.

117

son shows, drawing *cloisons* for infilling with colour, and their models can only have been the gorgeous metalwork which we know from such finds as the Sutton Hoo hoard; but neither the animals of the metalwork nor of the manuscripts could have given us the lean and hungry lope of the Ardross wolf. Another interesting comparison drawn by Dr Henderson is between the magnificent eagle from the Knowe of Burrian, Orkney, and

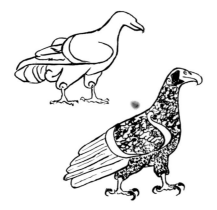

Fig. 38 EAGLES, Burrian slab and
Corpus Christi MS
After Henderson, *The Picts*

the eagle in the eighth-century MS 197a in the Corpus Christi collection at Cambridge. Here the relationship is so close in almost every detail that it is difficult to escape the conclusion that the artist of the manuscript is merely formalising the brilliant impression on the Orkney stone. The derivation of the calf of St Luke in the Echternach Gospels, in the Bibliothèque Nationale, from the little group of bulls found at Burghead on the Morayshire coast is not perhaps quite so immediately obvious, though the missionary Northumbrian who founded this monastery at the beginning of the eighth century, or someone in his company or among his followers, must have taken with him some sort of sketch-notes of the Burghead bulls, for the joint-spirals, far divorced from their original definition or musculature though they are, do repeat certain small details such as the secondary whorl in front of the shoulder and the swirling outline of the dewlap. None of the Pictish animals could have been reconstituted from the creatures of manuscripts or Saxon jewellery. It seems certain that in this respect cultural contact between the Picts and the south was one way; but the Picts also must have borrowed from the Saxons as they did from their Celtic cousins. Is the Pictish Beast, for example, derived from the biting beasts of the Book of Durrow and through that from Saxon jewellery? Alone of the Pictish animals it does not represent a real creature, yet the Picts seem almost to treat it as one, and their vivid hunter-pastoralist minds see it in terms of the living lines of animals familiar to them, even define its moving muscles with the whorl-convention.

I have referred to a possible totemistic or religious purpose in the symbols. This should not concern us here, except in so far as it might throw light on the artist's approach. It is Romilly Allen[1] who considered they had a religious significance. The late C. A.

[1] J. Romilly Allen, *The Early Christian Monuments of Scotland*, London, 1903, p. xxxvi et seq.

Fig. 39
FOREPART OF CALF OF
ST LUKE, Echternach
Gospels

Plate 69 STONE INCISED WITH BULL. Scotland—Burghead, Moray-
shire: Pictish, 7th century A.D. Height 33 cm.
British Museum, London

Gordon[1] believed the animal symbols were 'objects of power' to promote morale in a
farming and hunting community. Diack,[2] on the other hand, points out that the symbols
occur usually on sepulchral monuments and has no doubt that they were personal
insignia. He quotes Claudian's references to tattooing, as distinct from Caesar's picture of
blue-painted warriors, suggesting the symbols were tattooed on the bodies of the Picts
and denoted not tribal differences but social classes, which would as he says meet the
problem of the wide distribution of certain symbols, for social class divisions transcended
tribal boundaries. Nothing could be more natural than the transference of the personal
symbol to the commemorative stone. This interpretation would explain, too, the continua-
tion of the symbols from pagan into Christian times. It is true enough that the localisa-
tion of certain symbols, like the bulls in the Burghead area, may seem to favour the tribal
theory of totemic animal tattoos to which Lethbridge[3] subscribes and which may be
supported by such survivals as the name of my own clan, the Clan Chattan (the Cat
People); but there may be room for more than one interpretation of the symbols.

[1] *Proceedings* of the Society of Antiquaries of Scotland, Vol. XCVIII, 1965.
[2] F. C. Diack, *The Inscriptions of Pictland*, Aberdeen, 1944, pp. 27, 41.
[3] T. C. Lethbridge, *The Painted Men*, London, 1954, p. 70.

VII

The Christian Era (2)

The Golden Age

If the La Tène style matured rapidly after an obscure birth, that is still truer of the second great advance in the history of Celtic art, in full momentum from the second half of the seventh century until the beginning of the ninth. It is not difficult to sort out the contributory factors, but the achievement is none the less astonishing. First of those factors is of course the technical expertise and taste of the Celtic peoples, of which Ireland had become the main repository, and the La Tène style itself was not dead. A second factor is the end of the Irish church's isolation, bringing intercourse with Rome and a knowledge of new techniques and themes and even numbers of foreign craftsmen, some maybe driven westwards by the advance of Islam. A third factor, more elusive but surely very important, is that surge of devotional and missionary zeal which inspired Irish artists as the glory of conquest and heroic deeds inspired their predecessors. That sense of the symbolic that had made artists embellish and poets exalt the sword and shield now turned towards the Cross.

In spite of the bewildering influx of exotic ideas at this time, the renaissance of art in Ireland and in areas influenced by her took forms which are peculiarly Celtic. This needs to be said because often enough it has been claimed or implied that masterpieces of the Irish workshops and scriptoria are not truly Celtic but pastiches of foreign styles. The term Hiberno-Saxon has been widely used. I would not question its validity, but it has developed overtones that tend rather to underestimate the Irish element. It is not difficult to recognise the foreign contribution to Celtic art at this or any other time, but manifestly the exotic motifs are being selected and manipulated by someone imbued with Celtic traditions. One of those traditions is eclecticism; another is disdain of mere imitation; and it is a measure of the excellence of any piece of Celtic art how far what is borrowed has been transmuted by the artist's purpose. The supreme challenge now, however, lies in the fact that the Celt has to borrow and transmute not mere decorative motifs such as the palmette or the horses on Greek coins but the very faith itself behind a foreign inconography. Whether he succeeded or failed will be considered in due course, but what matters in the first instance is that he responded in a way peculiarly his own.

The ancient mastery of metal-working is resurgent again in the seventh and eighth centuries. It is even perhaps as central to this epoch as it had been in pagan times, and its techniques and treatments strongly influence the other arts, especially those of manu-

script illumination and stone sculpture. The scope of this chapter lies mainly within the bounds of religious art. The secular work of centuries, however, exerts a considerable effect, and it is a secular group, the brooches, which will be examined first. They come of a long ancestry, and they illustrate well the Celt's talent for absorbing foreign elements and adapting them to bring new life to traditions which would otherwise have declined.

Penannular brooches, together with bow fibulae, had been the garment-fasteners of the La Tène culture, and versions of them, still in bronze, developed in Ireland as early as the fifth century. La Tène motifs persisted on the terminals of the ring of the brooch, which had zoomorphic forms; the terminals grew into wedge-shaped plates and become the dominant feature. In the next two centuries the entire brooch becomes more massive and is more heavily enriched, the length of the pin increasing ostentatiously. An ornament of such proportions, its formidable pin sometimes twice the diameter of the ring, must have had great social significance, and undoubtedly became a badge of rank, possibly both secular and ecclesiastical. In the eighth century it attained its climax. The great terminal plates were linked by metal bars, for a time were joined completely, so that the brooch was really no longer penannular at all. Terminal plate and ring terminal were not only exaggerated but were emphasised by the richest decoration. Yet somehow this over-dramatisation was held in equilibrium by the deliberate simplicity of ring and pin, and the splendour never became barbaric. Anglo-Saxon jewellery is reflected not only in the techniques used, but in the style. Saxon patrons had a taste for glittering stones and faceted, light-reflecting settings, achieved by techniques such as chip-carving, filigree and *champlevé* enamels. While appreciating the technical skills of these processes as seen in the numerous Saxon objects coming into Ireland in the seventh century and after, the Irish workshops were selective and discriminating and used what they learned to enhance their own ideas. They picked on such features as the bright colours and bold bosses and rendered them much more effective by the taste with which they limited their use and offset them by relatively restrained surroundings. The silver brooch from Killamery, Co. Kilkenny, now in Dublin, is a good example of how effective the Irish jewellers could be in adapting foreign work. For the studs and lozenges one would, in a Saxon piece, find garnets or *cloisons*, though here in their unadorned settings the enrichments are emphasised by the contrast. Equally effective and even richer in detail is the Roscrea brooch in Dublin. In it the contrasts are reversed. The undecorated ring is prolonged by the plain-bordered terminal plates, but on closer inspection the borders reveal a pattern of the most delicate spirals, and there is a background of heavily-sculptured metal which would spring to life with every movement of the wearer's body. There are many such brooches, of varying merit. Two will be described more fully, two which are acknowledged as among the masterpieces of the jeweller's art.

The less well-known of the two is the brooch found at Hunterston in Ayrshire, now in the National Museum of Antiquities in Edinburgh. It is an annular brooch of silver, with fully-conjoined 'terminal' plates forming a massive crescent to balance the great wedge-shaped pin terminal. Every bit of the surface is opulent with intricate filigree

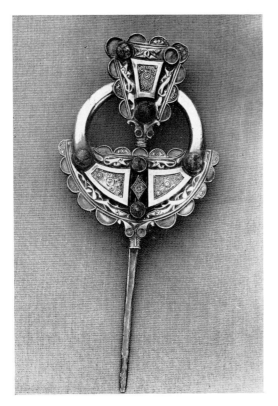

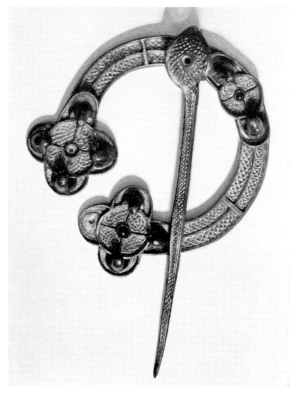

Plate 70 SILVER BROOCH. Ireland—
Roscrea, Co. Tipperary: prob-
ably 8th century A.D. Length
18.1cm.
National Museum of Ireland,
Dublin

Plate 71 SILVER BROOCH with gold inlays (the
larger 'Cadboll' brooch). Scotland—
Rogart, Sutherland: 8th century A.D.
Diameter 11.4cm.
National Museum of Antiquities of
Scotland, Edinburgh

decoration soldered to backgrounds of gold. The main panels contain zoomorphs, and
there are zoomorphic creatures at the junctions of the great plate with the remainder of
the ring. Such filigree is of course a characteristic Anglo-Saxon technique, and the
brooch has been ascribed to a Northumbrian craftsman, Northumbria embracing the
whole of what is now south-east Scotland. The link with Germanic art is perhaps as
marked as in the Lindisfarne Gospels, described later in this chapter. The shape of the
brooch, however, is manifestly Celtic, and the two panels of cast-work spirals in relief on
the reverse are so fluid and free that it is difficult to believe no Celt had a hand in it. So
delicate is the detail that one must examine it under a glass to appreciate the masterly
skill. Even the edges of the pieces are decorated with panels of interlaced work. Also in
this museum, and technically as fine, is the fragment of a brooch caught up on the point
of a pick by a man digging a drain at Dunbeath, in Caithness, in 1860. The pick shattered
what might well have been the outstanding example of its kind. This fragment is of silver
inlaid with gold, and the principal decoration consists of two panels of zoomorphs whose

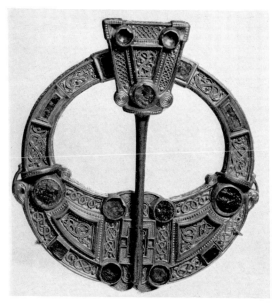

Plate 72 SILVER BROOCH, partly gilt.
Scotland—Hunterston, Ayrshire:
Hiberno-Saxon, 8th–9th centuries A.D.
Diameter 12.1 cm.
*National Museum of Antiquities of
Scotland, Edinburgh*

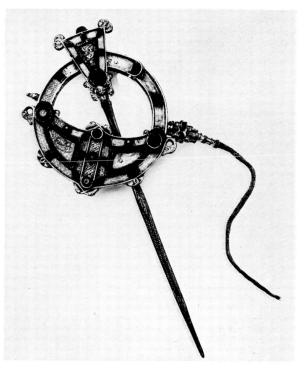

Plate 73 BROOCH, bronze gilt (known as the
'Tara' brooch) Ireland—Bettys-
town, Co. Meath: 8th century A.D.
Diameter 8.9 cm.
National Museum of Ireland, Dublin

bodies are infilled with tiny gold granules bounded by gold wire. It is of relatively little importance whether those two brooches were made within the Gaeltachd or in the neighbouring Northumbria, because the culture which produced them had no hard and fast territorial boundaries. Quite early in its history the Hunterston brooch was successively the property of a Viking and of a Norse-Celtic family, as the runic inscriptions on its reverse record, and it is worth noting that there is another brooch of the type, though in less fine condition, in the National Museum in Oslo. The masterpiece of this group of ornaments in several ways closely resembles the Dunbeath fragment. It is the famed 'Tara' brooch, found in fact not at Tara but near the mouth of the Boyne, at Bettystown. It is smaller than the Hunterston, being only three and a half inches in diameter, but it excels the other piece in the exquisite perfection of its detail. A portion of wire chain attached to it seems to indicate that it was made as one of a pair to fasten a cloak over both shoulders. The man for whom the Tara brooch was made was a connoisseur, whatever else he may have been. The front of the brooch has the dramatic qualities common to its group, qualities which in this case can be seen to the full only in a much-enlarged photograph with angled lighting, when the surface becomes a little world of its own out of the shadows of which emerge such creations as the dragon-head glaring from the junction of

pin and terminal, the little reptiles creeping like baby alligators from the egg, the confronted human masks of dark glass with their ancient, inscrutable, suggestively Celtic mien. The supremacy of the Tara brooch lies not so much in its consummate craftsmanship, for that is at least approached by the two Scottish pieces, but rather in its miniaturised projection of that dream-world which for the Celt always lurks on the fringes of awareness. If Christianity is the force which released the Celtic renaissance of this time—and this is scarcely in doubt—preoccupation with primordial mysteries still quickened the imagination of artists, no doubt especially when dealing with secular commissions such as this must have been.

Turning to the religious objects, those with the most markedly foreign accent are the little group of portable, 'hip-roofed' shrines or reliquaries. The idea of making such boxes in the form of a house is in itself continental and in a later age developed in Europe to produce such pieces as the reliquary of St Samson at Rheims and, at Ambazac, the reliquary of the Theban Legion, the roof of which is complete with dormers. The simple form of the Irish shrines, with their sloping gables, does seem to be in the likeness of native oratories, as for example the Gallarus or St Columkille's House at Kells; but if

Fig. 40
PIN-TERMINAL,
Tara Brooch
Drawing by author

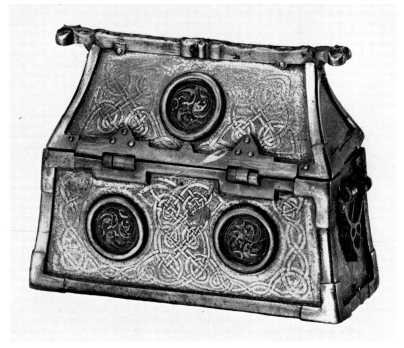

Plate 74 SHRINE OR RELIQUARY, inlaid enamel and garnets, with later runic inscriptions. Found in Norway. Ireland: 8th century A.D. Length 13.5cm.
Nationalmuseet, Copenhagen

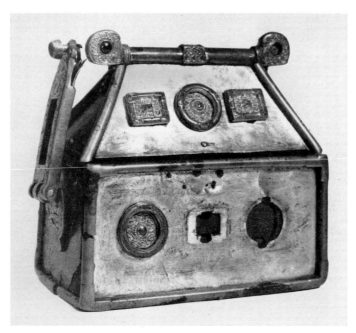

Plate 75 SHRINE OR RELIQUARY, wood plated
with bronze and silver. Formerly at
Monymusk House, Aberdeenshire.
Scotland: about 700 A.D. Length 17.9cm.
*National Museum of Antiquities of
Scotland, Edinburgh*

one begins to dissect the decoration one is left with a handful of very Saxon fragments. This is perhaps especially true of the Emly shrine, now in the Boston Museum of Fine Arts, the lattice pattern on which recalls some of the Sutton Hoo articles, although the inlay is not on an enamel base but on the yew-wood carcase of the box. Even the interlace pattern on the Copenhagen shrine resembles the interlace borders of the gold shoulder-clasps from Sutton Hoo. In some respects the member of the group with least foreign accent is the Monymusk reliquary, known also as the Brecbennoch of St Columba, in the National Museum of Antiquities of Scotland, the only one which possibly did not originate in Ireland. Treatment of the surviving detail, whether the enamels or the relief-work of the inset plaques, or the barely-perceptible interlaced zoomorphs dot-outlined on the surface of the surface plates, is carried out with traditional delicacy. Shrines of this sort were made to be carried on the breast, supported by a strap attached to the clasps at either end. Perhaps their most Celtic characteristic is the way in which the decoration is assembled or disposed. On the Brecbennoch the mature, sophisticated distribution of decoration, contrasting delicately-patterned silver surfaces with the bold shapes of bronze mouldings and the bright colours of enamels and gold medallions, has centuries of experience behind it, though these contrasts are perhaps new to insular art. This faultless taste must have been reflected by all the shrines in their original condition. Dr Georg Swarzenski has

125

pointed to the subtleties of such decoration in the case of the Emly shrine;[1] and typical features can be seen on the damaged Lough Erne shrine in Dublin: the ornate 'ridge-pole', the triple medallions on the front, one on the roof, two in the wall, the fittings at the ends for the carrying-strap. Being small and portable, these shrines are widely distributed, although the total number is not great. If Scandinavian examples are Viking loot, those at Chur and Namur and also the fragments at St Germain may have been carried by travelling clerics.

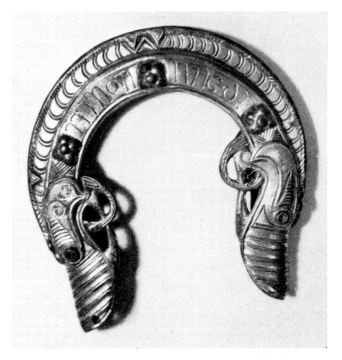

Plate 76 CHAPE, silver. Scotland—St Ninian's Isle, Shetland: 8th century A.D. Width 8.6cm.
National Museum of Antiquities of Scotland, Edinburgh

Possibly loot too, but more probably buried for protection against Viking raiders about A.D. 800, is the extraordinary hoard of silverwork excavated on St Ninian's Isle in Shetland by Professor A. C. O'Dell in 1958, a hoard described by Dr Bruce-Mitford[2] as 'the most interesting assemblage of Dark-Age metalwork found in the British Isles', the Sutton Hoo hoard apart. The articles vary in their places of origin, and in time range from the seventh to the eighth century. They include a number of bowls, among them the most northerly example of a hanging-bowl found in Britain, the only spoon in the country dateable to its period, a sword-pommel, three conical objects which appear to be mounts

[1] The Boston Museum of Fine Arts, *Bulletin*, Vol. LII, 1954, p. 50.
[2] R. L. S. Bruce-Mitford in *Antiquity*, Vol. XXIII, 1949, p. 262.

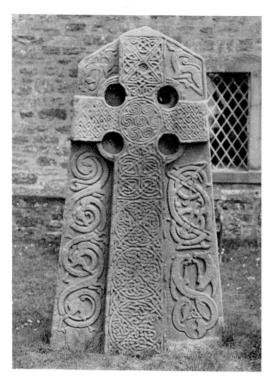

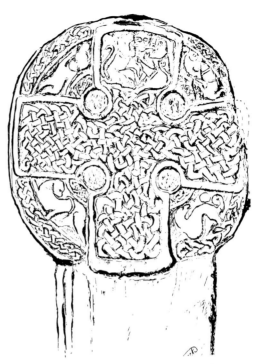

Plate 82 SANDSTONE CROSS SLAB. Scotland—
Aberlemno churchyard, Angus:
Pictish, 8th century A.D. Height 2.28m.

Fig. 43 KIRK BRADDAN STONE, Man
W. Cubbon, *Island Heritage*,
Manchester, 1952

appear to have been strongly localised. Under the rule of Nechtan early in the eighth century the Picts had a close association with Northumbria, and it is probable that quantities of manuscripts were brought north and that the sculptors imitated the illuminated decorations, first tracing them in fairly shallow renderings but later cutting more deeply and bringing more and more originality to the patterns. At the same time they developed their representational art with a taste and skill which one would look for in the successors of the sculptors of the Class I stones. Some of this work may be secular. The battle scene on the reverse of the big cross-slab in Aberlemno churchyard could be a straightforward piece of narrative, but the cross on the front of the slab is uncompromising. The Eassie slab combines angels and warriors and exquisitely-rendered animals, some with the ancient haunch-whorl. The great Hilton of Cadboll slab in the National Museum of Antiquities, dating from about 800, has a hunting scene which recalls the Banagher cross in Ireland, but the interpretation is much more spirited; it is combined with symbols, with a panel of scrolls or eddies in the best La Tène tradition, which together with the vertical panels of beautifully-executed vine scrolls with birds Dr Henderson associates with Mercia.[1] The freedom and relative realism of scenes such as those on the Aberlemno and Cadboll slabs contrasts with the hieratic, almost abstract quality of

[1] Henderson, ibid., pp. 154 and 122.

135

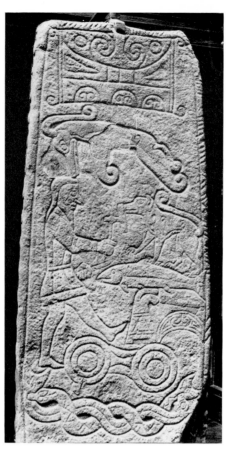

Plate 83
STONE INCISED WITH
SYMBOLS AND A FIGURE.
Scotland—Golspie,
Sutherland: Pictish, 8th
century A.D. Height 1.83m.
*Dunrobin Castle Museum,
by courtesy of the Countess
of Sutherland.*

figure sculpture elsewhere in the Celtic west, and it would seem the Pict was less shy of the human figure than were his neighbours or his Celtic forebears. One might say he had the best of both worlds, for while at times he could tell a plain story almost like the sculptors of Trajan's column he could equally participate in the mysteries of symbolism and sense that equilibrium between tensions which marks so much of the best Celtic art at all periods. The Pict's influence on other peoples is less easy to establish than theirs upon him. However, a monument such as the Kirk Braddan stone on the Isle of Man has a cross with an irregular nimbus markedly like the same feature on the Eassie stone and 'monsters' in the angles of the cross in the style of the No. 4 cross-slab at Meigle. R. B. K. Stevenson considers that Pictish work influenced the sculptors of the Iona crosses early in the ninth century.[1]

The iconography of Class II Pictish stones calls for some comment because there is nothing quite like it in the whole range of Celtic art. We have, first, the strong element of realism. The Class I animal symbols were realistic too, but basically they were conventions, whereas the Class II animals are often quite naturalistic studies, as for example

[1] *Kolloquium über Frühmittelalterliche Skulptur 1970* (University of Heidelberg), Mainz (to be published).

136

the horses, or the doe suckling its calf on the No. 1 stone at St Vigean's, or even the walking man on the stone from Golspie which Romilly Allen regarded as the most important monument at Dunrobin. On the other hand, there is a range of grotesque creatures, some animal, some human or semi-human, such as the monster with head at either end at Gask, or the beasts with a common head at Meigle, or the conclaves of beast-headed men at Murthly and at Kettins. Those creatures have no religious significance. Naturalistic animals are easily explained as the studies of hunter-artists. Where did the monsters come from? Mr Stevenson has put it to me that they might be allegorical and symbolic bestiary creatures, part of the same world as angels and the symbols of the Evangelists. Dr Henderson has suggested[1] that some of the scenes depicted, as for example the battle on the Aberlemno churchyard slab, are derived from secular embroideries and that there may have been a native tapestry tradition; ivories too are relevant. Like Mr Stevenson, she holds that the monsters were probably bestiary creatures. She refers to an Anglo-Saxon version of *The Marvels of the East* with illustrations showing creatures similar to the Pictish ones, and to the monster lore current in Europe in the eighth and ninth centuries, a lore which may well have come into being earlier. The animal-headed men are possibly borrowed from foreign traditions, which would explain the not-uncommon centaur. Like all Celts, the Pict was an inveterate borrower of motifs.

Manuscript illumination introduced a new dimension for the Celtic artist. His traditional media of stone and metal provided him with inborn guidance and with inspiration in plenty. The vellum surface was another importation from the Mediterranean and beyond, alien to him as the basis for an art form, but the infinite possibilities offered by it made visualisation of the strange world of his imagination more attainable than ever before. The resulting achievement is unlike anything in the religious art of other peoples. Christianity supplied more than the motif. Christianity, in that it required the artist to render the Gospels visually for an illiterate world to read, provided him with a new sort of challenge. It provided also the dedication which sustained him through many adversities. But the miraculous imagery with which he covered the pages of the great Gospel-books was culled from a dream lore which men of his race had told to one another ever since they emerged from the Bronze Age, a lore kept alive round the fires of Hallstatt and La Tène chieftains, those tales of heroes and monsters which are part and parcel of early Welsh and Irish literature. The new renaissance is far too brilliant to be the mere telling of old tales with new meanings, the *Tarasque de Noves* presented as Jonah and the Whale. That sort of thing was well enough for provincial Gaul, whose subjection was reflected in the debasement of her art, but the Christian experience was a totally different matter and fostered the rich fancies of the Celtic mind.

There must have been a very great number of illuminated manuscripts in and around the eighth century. They form a new chapter in the development of Celtic art, and many scholars have even questioned whether it is properly Celtic at all. This is no new question with a subject so eclectic as Celtic art. That many of the elements which have gone into the

[1] Henderson, ibid., pp. 135–6.

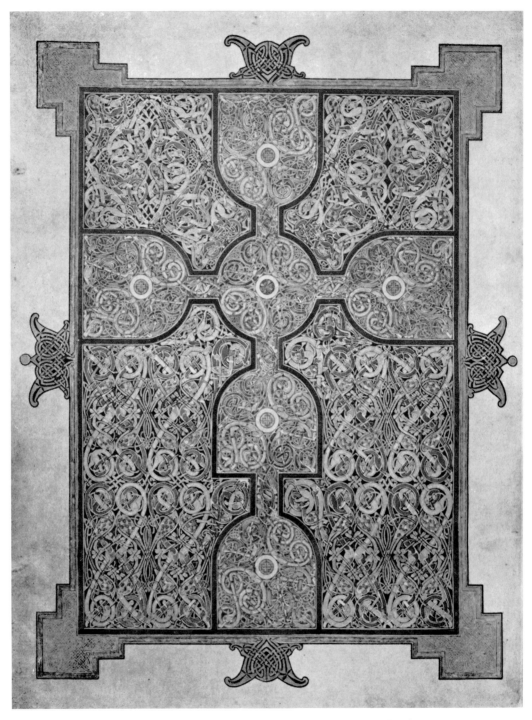

Plate 84 THE LINDISFARNE GOSPELS, second cruciform page. England—
Northumbria: beginning of 8th century A.D. 33 × 24.3 cm.
British Museum, London, by courtesy of the Trustees

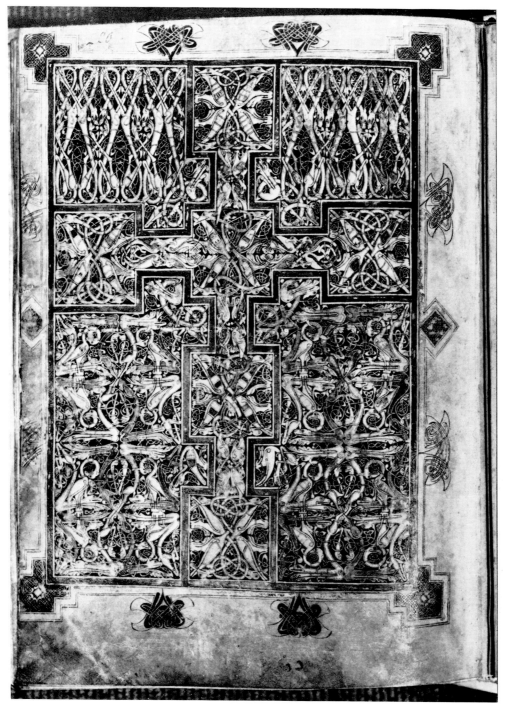

Plate 85 THE LICHFIELD GOSPELS, cruciform page. Probably Wales: early
8th century A.D. 29.2 × 22.3 cm.
Cathedral Library, Lichfield

making of the manuscripts are foreign is not in doubt, foreign that is to Irish practice, but without those elements no great achievement was possible. Such an early manuscript as the Cathach of St Columba, evidently purely Irish in origin, is as one writer puts it 'nourished solely from the poor vocabulary then available to culturally isolated Irish art';[1] while the great Durrow manuscript, as we saw in the last chapter, strongly reflects the outside world and may well indeed not have been done in Ireland at all. Now in the eighth century we come upon the masterpieces of the new style of illumination. What part did the Celtic peoples play in producing them? Some earlier manuscripts clearly show the effect of close association with Rome, and not all the scribes, especially in continental scriptoria such as Echternach or Trier would be Irish, which could in part explain the inflow of Saxon ideas. Arcades and columns framing the canon-tables come from the classical world, and there are beasts and birds obviously of Near-Eastern origin. In continental manuscripts such as the Maihingen Gospels, on the other hand, there are marked Irish elements. Where then did the brilliant school of manuscript illumination known as Hiberno-Saxon come from? It develops relatively quickly. This could hardly have happened if it were dependent on isolated missionaries returning to Ireland from abroad. There must have been an area where Irish traditions mixed continually with Saxon and other influences, an area moreover whose direct route to the south was always open, and this area could only have been Northumbria, where the Irish mission had long been established, and where so many of the finest early manuscripts have survived. Claims for the English provenance of certain early gospel books do not really affect claims for their belonging to the Celtic world, and indeed so Celtic are they in spirit, to say nothing of the Irish script in which the texts are written, that they may be adduced as proof of the strong degree of Celticisation in Northumbria at this period. Even manuscripts which we assume never to have left the area, such as A.II.10 in the Cathedral library at Durham, may be characteristically Irish, and Nordenfalk confidently notes the close resemblance between the interlace on the Durham fragment and that on the Carndonagh and Fahan Mura crosses.[2] The Irish missions in Northumbria at this time were clearly feeding back ideas to their motherland.

Two great works in particular illustrate the achievement of the early eighth century in illuminated manuscripts: the Lindisfarne Gospels and the Book of St Chad, also known as the Lichfield Gospels, though it came to Lichfield only in the tenth century by way of Llandaff, from unknown origins. Even among the authoritative writers on the subject, few have claimed for Celtic art that it is more than supremely beautiful decorative art; but the two Gospel-books mentioned, together of course with their great successor of the early ninth century, the Book of Kells, take us far beyond such limitations. In a great work of religious art the didactic element matters much less than the capacity to exalt. Even Paulinus of Nola in the fifth century, whose recommendation of sacred wall-paintings was for a very practical purpose, claims of the people that 'in wonder at the

[1] Carl Nordenfalk, *Acta Archaeologica*, Vol. VIII, 1937, p. 156.
[2] Ibid., p. 170.

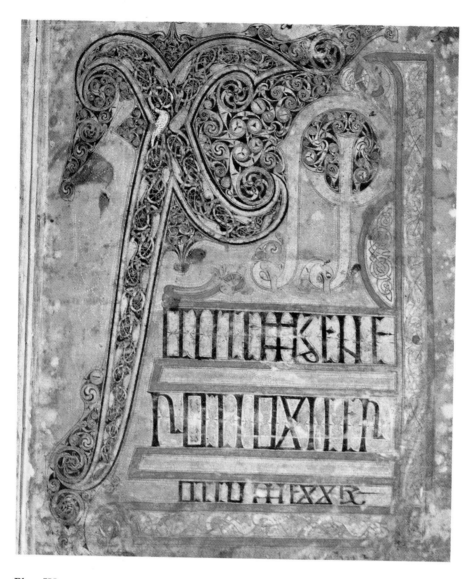

Plate IV THE LICHFIELD GOSPELS, Chi-Rho page. Probably Wales:
early 8th century A.D. 29·2 × 22·3cm.
Cathedral Library, Lichfield

paintings they forget their hunger'. What is needed to rouse this wonder in a people un-accustomed to the sort of imagery that appealed to the people of Campania in the fifth century, or for that matter to ourselves to-day, will be touched on in the next chapter. Strange as they may seem, the splendour of those pages is unmistakable. One thinks of choral music, in which words are trivia and the sheer beauty of sound is all. Words, truly enough, are the framework on which the beauty of the Gospel-books is built up, but we do not need the words to apprehend the praise and tribute which is being offered or to sense the exaltation of spirit in which they are created. The Chi-Rho pages of both books—perhaps especially Lichfield—are the supreme examples of this art, the Book of Kells apart. The contributory influences are complex. In the maze of eddies and swirls within the initial letter can be discovered elements as purely La Tène as the Birdlip mirror-back, whereas the interlacing birds within the outline of the letter could be Coptic or Italian. Again, the formal, organised lay-out of the intricate carpet-pages, with their dominant cross, stands out with Mediterranean clarity; but the improbable creatures disporting from edge to edge of the page belong to another world, that primeval 'Tolkien' world of the legends.

The most foreign element in these books is the Evangelist portrait which precedes each Gospel. In some cases such as the Book of Dimma (Trinity College, Dublin) there is an awkward if engaging compromise between representation and symbol; with Lich-field and Lindisfarne the saint himself is a copy or an adaptation of a Mediterranean original, rather Byzantine in posture and treatment, and the same is true of the animals which accompany the saints. So derivative are these pages that even the Celt's ancient embarrassment when faced with the need to depict man is not obvious, and there is little of that pleasing ingenuousness which marks, say, the Last Judgment page in the St Gall Gospels.

Technically, both the Lichfield and the Lindisfarne books are brilliant, and compared with the Book of Durrow they show a considerable advance in knowledge of pigments. The Lichfield Gospels have suffered seriously at various stages in their history and have been badly affected by damp, but curiously this has brought a certain sombre beauty of its own, a gloom through which the surviving colours glow like stained glass. In figure style Lichfield may be nearer to Dimma. Dr Henry notes a certain monotony, a 'sort of frozen perfection' in Lindisfarne which is not present in Lichfield.[1] As Dr Henderson has wisely suggested to me, however, there is no need to place these two manuscripts in order of merit. We know with reasonable certainty that the Lindisfarne Gospels are the work of Eadfrith, bishop of Lindisfarne from 698 to 721, as recorded by Aldred, who added an Anglo-Saxon colophon in the later tenth century, and as it is not completed in all its details Eadfrith may have worked on it towards the close of his life. It is more than likely that he also did the illuminations. These magnificent Gospel-books were designed for use on the altar, and were normally preserved in a metal *cumdach* or shrine.

How far this 'Golden Age' of the seventh and eighth centuries was the inheritor of

[1] Henry, ibid., p. 195.

the ancient Celtic art tradition has been disputed again and again, but Dr Henry in the conclusions at the end of Volume I of her *Irish Art* makes it clear that the Irish artists were building on a firm pre-Christian basis. Not only did they use old motifs and styles but, more important, their approach was little changed. They had to make concessions in many things: their church was preaching an imported idea, and the language and the outer signs and symbols by which this idea was conveyed were all alien to the insular peoples, but the artist, like the priest himself, had to make all this credible to his own people in ways which would not add to the barriers and increase misunderstanding. Neither in argument nor in art was the rational and measured approach of the classical world likely to succeed. Dr Henry recalls the accusation of a 'syllogism of deceit' levelled against Irish scholastics,[1] although deceit is a hard word to use of the artists, who could not put aside their very real aversion to those monotonous statements of the obvious that render dreary and dull so much second-rate and particularly provincial classical art. However much he might admire the achievements of Mediterranean civilisation, the insular artist could take no pleasure in creating works which were without the tension of uncertainty, the challenge of the unpredictable. In the two centuries under review the mental conflict of the artist must have been immense. Roman pressures here encountered a resistance never met with in countries which had known Rome's military domination, and to the spiritual pressure was added the flow of new artistic ideas and technical skills. But the Celtic attitude is fundamental. Even the intricate compass-work and controlling grilles which, it has been proved, were used in devising the pages of the manuscripts, as indeed they had been with other media for centuries past, merely supplied the *points d'appuis* for tracing more elegant illusions. Yet their 'illusions' played as valid a part in human aspirations as the calculated perfection of the Greek ideal.

At the beginning of this chapter the question is left unanswered whether the Celtic artist succeeded in his response to the challenge of Christianity. May we, in fact, include some of the works described here among the major achievements of Christian art? If we agree with those critics who admit them to be nothing more than superb decoration, then of course we cannot so include them. I hope, however, that we have seen sufficient evidence to prove that some of these works surpass the limits of mere decoration, that they may even express abstractions and emotions in ways that baffle purely representational artists. It can be argued that the Christian message is too profoundly revolutionary to be contained in the sort of imagery which Christendom inherited from the pagan ideals of Greece and Rome. The Celt's instinctive preference for symbols, his feeling (if we read it rightly) that deity is inherent in created things rather than a human presence writ large: these must surely have found a new release through the thought that God is not a figure either on Olympus or yet on Calvary, but the concept of all-forgiving Love. For the peoples they were made for, at least, the Gospel-books or the crosses, even a sacred vessel like the Ardagh chalice, as aids to devotion must rank among the world's greatest masterpieces of religious art.

[1] Ibid., p. 215.

VIII

The Christian Era (3)
The Pagan Irruptions

A renaissance of Celtic art in the Christian era had been fostered by the relative peace of Ireland in a warring world. Not that the Irish were at peace among themselves: constant strife occurred between their kings, even between the religious establishments. But a good deal of this may have been sheer Celtic bombast and posturing, and it seems to have done little to disrupt the work of scribes and artists. Foreign influences were not imposed upon them by military or political domination, but were absorbed by way of trading and missions and peaceful intercourse with the outside world, so that the artists could select or reject what they would. Then, in the last decade of the eighth century, the Irish were suddenly confronted by the perils of this outer world. The Vikings, men untouched by the precepts of love, mercy and forgiveness with which a despot or conqueror in Christendom could at least be reproached, descended on Lindisfarne and sacked it, began to lay hands on the Hebrides, and the ninth century had barely dawned when their longboats appeared off Iona itself for the *vikingr* to put it to the sword. In 807 the abbot fled to Kells in Ireland.

Eras do not fit neatly into centuries, and what we have called the Golden Age did not of course end in the year 800. One at least of its greatest masterpieces was completed in the shadow of the new reign of terror, and laborious and beautiful work continued to be done even when the Northmen had come to dominate the Irish Sea and were sending their forays deep into Ireland itself, burning, killing, enslaving and looting, carrying off those splendid relics which now grace in such numbers the Scandinavian museums, ironically saving them for posterity.

Even as late as the ninth century there were no fine cities in Ireland for the Vikings to sack, as later they were to do on the Continent. The 'cities' of Ireland were communities like that of Glendalough, a secluded valley site at the confluence of two small rivers an hour or two south of Dublin. The stone buildings surviving there are obviously a little later in date, and in the ninth century all but perhaps the church would have been timber structures, easily destroyed and equally easily rebuilt. The round tower, like its fellows in Ireland and the two or three outliers in Scotland, although called a *cloictech* or bell-tower, must have been built mainly for the security of valuables and as a refuge for the people, and usually the door is a man's height at least above the ground. However, there seems no good reason to infer from what we know that the communities which produced such

glorious metalwork and manuscripts lived under primitive conditions, for the timber buildings may have been well wrought and were probably richly furnished with hangings. One visualises chambers not perhaps with the elegance or dignity of dwellings stemming from the Roman colonial heritage across the water, but boasting colour and even some luxury, certainly a bountiful hospitality stimulated by the perfume of good wine and by the resinous odours of riven and dressed timber, appropriate setting for an art which appealed urgently to the senses. Colour is an element that cannot be emphasised too strongly, for delight in it was certainly not limited to the metalwork and manuscripts; it must have embellished stone and wood as in the pagan centuries.

When the monks of Iona retreated to Kells in 807 they carried with them, uncompleted, perhaps the most marvellous of all works of art of the Christian Celtic era, 'the great Gospel of Columkille, chief relic of the Western World', as the Annals of Ulster describe the manuscript known to us as the Book of Kells (Trinity College, Dublin). There has been much speculation about how much was done on Iona, how much at Kells. Maybe—Dr Henry cites it as a possibility[1]—the designer of the manuscript, the Abbot Connachtach, died in the raid of 802; but many artists carried out the work, and they were among the refugees who came to Kells. Like other masterpieces of the Irish School such as the Gospel-books preserved at the Vatican and in Leningrad, the Book of Kells is a 'luxury' work, intended to lie on the altar. Among its contemporaries, however, it has no rival. It embodies all the vigour and power of invention and impeccable taste of Irish art at its best, yet almost every page of it reflects those many foreign influences, often exotic influences, which at all times were essential to rendering the Celtic genius fully articulate. The whole basis of the manuscripts is, of course, 'foreign', as indeed the concept of the gospel-book and the Gospels themselves are alien to the native tradition if we accept its aversion to anthropopathy; but all artistic inspiration needs the tight rein of an imposed discipline if it is to materialise as a creation of lasting worth, and the Irish monks found theirs in the need to purvey with some precision the precepts of their religion. Not only had they to convey their message in a foreign language, the Latin which they put on parchment in their own majuscule script; they had also to accept certain conventions in the page lay-out such as the canon-tables originated by Eusebius. Finally they had to incorporate such accepted Christian imagery as representations of the Evangelists. For these they used as their models the pictures which had become familiar to them in their intercourse with the rest of Christendom. Obviously they knew well the splendid manuscripts coming into being in the eighth century under the Carolingians. Here it is worth remembering the traffic was not one way for, as Dr Henry emphasises,[2] such achievements as the Psalter of Charlemagne in Paris and the Lectionary written by Godescalc for Charlemagne and Queen Hildegarde were themselves evolved under the influence of the Insular school through such men as Alcuin. The Book of Kells, after all, not early among Irish manuscripts, is contemporary with the earliest Carolingian work.

[1] Henry, *Irish Art During the Viking Invasions*, London, 1967, p. 70.
[2] Ibid., p. 67.

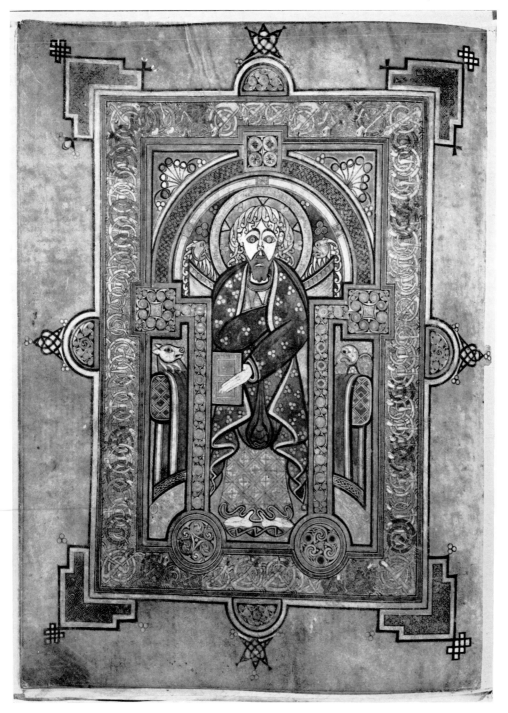

Plate 86 THE BOOK OF KELLS, folio 28v (St Matthew). Dalriada region—
Iona/Kells scriptoria: around 900 A.D. 33 × 24cm.
Library of Trinity College, Dublin

Much of the Eastern influence apparent in it was absorbed direct, and those pages which portray the Virgin or the Arrest of Christ at once recall mosaics looming in some Byzantine apse. In this era Byzantine forms dominated the art of all Christendom, from the remote settlements in Ireland to the even more isolated communities of the Upper Nile in Nubia.

So prominent is the foreign contribution to the art of the Irish manuscript illuminators at this time that it is not surprising that some are critical of its inclusion in a history of Celtic art. Hiberno-Saxon is not altogether an adequate label for it, for it is a compound of several cultures. Yet it is a compound with an identity of its own, as one might say of modern Western art. The illuminator does not borrow merely to copy but uses the borrowed material to create something completely new and strongly imbued with his own notions. If the Byzantine origins of the Evangelist figures are as manifest as the Coptic origins of the interlaced borders or the Anglo-Saxon sources of much of the jewelled detail, no page in its totality could be mistaken for any of those things. There is a presiding genius, a genius that is quite familiar. One recognises, for example, the unerring taste and the sophisticated handling of all decoration for their La Tène ancestry. The organisation of each and every page is superb, but this again may point to a Saxon element and beyond that over the southern horizon; but then again the humanity which infuses it all with warmth is the contribution of the Irish scribe. It is he too who has raised the decorated page to the stature of a great work of art. The major Gospel-books, Kells, Lichfield and Lindisfarne, are masterpieces as eloquent of their times as any. Their pages open the door upon the elusive fancies of the Celtic mind more dramatically than does any work of pagan times. The great Monogram page of the Book of Kells is not merely 'the most elaborate specimen of calligraphy' ever executed: it is a revelation of the marriage of pagan superstition and Christian belief, quite as spiritually significant as Michelangelo's great manifestation on the ceiling of the Sistine Chapel. All the restless heroics of La Tène are here in interlace and swirl, and in all the creatures real or allegorical that lurk in this beautiful jungle; but now terminals flower into the benign heads of angels and the rats nibble the Eucharistic bread under the eyes of two cats in a new sort of complex symbolism, with a flash of humour thrown in. This is something quite different from pagan humanism easily slipping on the cloak of Christianity, putting a beard and halo upon a god to identify him with Christ or saint. In these pages we see the laborious, if not reluctant, emergence of reverence for the Son of Man in a people which may traditionally have had little reverence for man above the rest of creation. In the Evangelist pages the human form does dominate, though for all the debt to Byzantium there is little of the aloofness and austerity of Byzantine renderings. Matthew and John even look a trifle apprehensive, understandably no doubt as their symbol-beasts are undomesticated creatures clearly derived from pagan menageries, complete with their 'joint-spirals'. The only really uncompromising Christian element in the composition is the huge initial 'P' around which the whole page is constructed, prominent not only as a feature of the composition but as a symbol, and symbolism is of course second-nature to the Celt.

In media other than the manuscripts, the art of Ireland and her neighbour-areas suffers a recession during the ninth and tenth centuries. It is not that superb works of art were not produced so much as that the traditional media of metalwork and stone were more inflexible, less adapted to agile compromise than the new dimension of parchment. The stresses and anxieties of these two centuries probably drove the artist nearer conformity to continental religious art concepts, and further from traditions that spelt isolation, and for the metalworker and sculptor new ways were harder to learn. The sculptors did manage to achieve some remarkable things, as we shall see, but the standards of metalworking declined, especially in techniques. Detail is much less delicate in execution, and the intricacies of the Ardagh chalice seem centuries away. There is little doubt the Viking invasions had much to do with this decline. Metalwork was the favourite loot of the invaders, and many Irish pieces and fragments of pieces attributable to this time are, as I have said, preserved in Scandinavian museums. Craftsmen must have been discouraged from devoting days and months to laborious work that might be fated to have a short life in the church for which it was destined, and tried to get their effects with least effort, using such means as coarser filigree, although a decline in quality already seems to have set in before the Vikings came.

Some of the best of the metalwork took the form of bell-shrines and croziers. Most are in Ireland, but there are a number in Scotland and a very few in Wales. Just as the shrines were made to encase venerated bells, so the crozier-cases usually enclose the yew-wood staffs used by venerated men. The resulting form is distinctive. It appears on many carved stones, and continued to be used in Celtic churches such as those of the Culdee

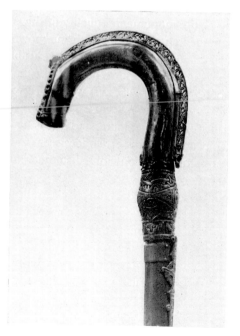

Plate 87
THE 'KELLS' CROZIER, bronze. Ireland: 9th–10th centuries A.D. Knop refashioned 11th century. Width of crook 18.8 cm. *British Museum, London, by courtesy of the Trustees*

communities in Scotland, until their absorption in the early middle ages. The wooden original was of course a simple walking-staff similar to the *cromach* still used in the Highlands of Scotland. Characteristic ninth- or tenth-century cases are those of the Toome crozier in the Ulster Museum and the Kells crozier in the British Museum. Decoration is mainly confined to the crooks and the knops. The knops are the principal ornamental areas and must have helped to make the croziers quite splendid when they were new, though on close examination there is neither the spontaneity nor the finish of earlier work. The small recessed compartments on the Kells knops are filled with interlaced devices and with little traditional intertwined animal compositions of considerable charm. However, these show nothing like the confident, uninhibited work of the great periods, but rather the conscientious embellishment of a prized relic in a time of trouble when no man knew what the next day might bring. The splendid effect I have referred to came less from craftsmanship than from skin-deep embellishment. The Kells crozier, for example, had silver foil beaten into the metal surfaces and the crozier of St Mel (St. Mel's College, Longford) had gold foil. All the vision in them is backward-looking, and indeed the flow of new ideas does not become apparent until the impact of Norse art-forms begins to take effect in the tenth century, when Ireland was experiencing a resurgence of national awareness under Brian Boru. The little bronze Crucifixion plaques of the ninth century are interesting (National Museum of Ireland and National Museum of Antiquities of Scotland); the debt here is to Carolingian art and the artist seems to be moving painfully on towards the Romanesque. The two plaques are similar, rectangular openwork compositions dominated by the Christ-figure, the four spaces filled by angels and by the two soldiers, Longinus piercing Christ's left side with his spear. The date seems to be around 900. Although impressive, they have not the monumental quality of the Athlone Crucifixion. There is, however, a certain monumentality in the book-shrine known as the Gospel of St Molaise, the 'Soiscél Molaise' (National Museum of Ireland). This has been modified at some time, after being damaged, but seems to have been one of the achievements of the period of Brian Boru. Such book-shrines (*cumdach*) were fairly common. This example attains much of the solemn feeling of the great crosses, and it is particularly true of the figure work. The sculptural quality of the little figures and beasts flanking the cross enriched with gold filigree is remarkable, and here the artist does seem to be drawing on that traditional sense of symbolic mysticism which contributed so much to earlier Celtic art.

Secular metalwork of the period is represented mainly by jewellery, and this is markedly influenced by the Norse invaders. One type of brooch, decorated with silver rivets, has in fact been called a Viking type, and some of them may be the work of Norse artists, possibly in Ireland or in England. Another type of brooch common at the time is the so-called 'thistle' brooch, deriving its name from the massive cross-hatched spheres that terminate the ring and the dagger-like pin, each sphere having a small projection like the petals of a thistle. This type, which has been found in Scotland and Norway as well as Ireland, is a complete break-away from the traditional form of the penannular

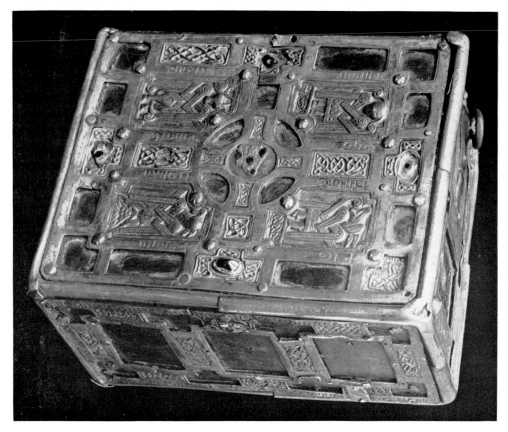

Plate 88 BOOK-SHRINE, bronze, known as the 'Soiscél Molaise'. Ireland—Co.
Fermanagh: about 1000 A.D. Length 11.6cm.
National Museum of Ireland, Dublin

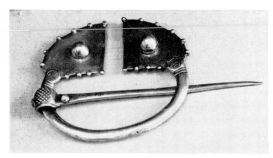

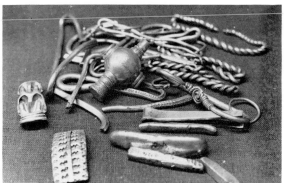

Plate 89 PENANNULAR BROOCH, silver.
Ireland: 10th century A.D.
Diameter (extreme) 12.2cm.
*National Museum of Antiquities of
Scotland, Edinburgh*

Plate 90 SILVER HOARD, with ingots and
fragment of 'thistle' brooch.
Lahall, Lier, Buskerud: about 930 A.D.
National Museum, Oslo

brooch, and might be thought to be a Norse importation were it not that it appears—as Dr Henry records—on carved figures as though part of normal Irish wear.[1] It could be significant that a fragment of such a brooch is among the broken-up, and presumably looted, silver in the hoard from Buskerud in the National Museum in Oslo.

The recession of Celtic feeling is more marked in the stone sculpture of this period than it is in the metalwork, though in Ireland at least it is not so much a recession as a very positive new phase. It has two special features. First, representational art becomes dominant and scenes from the Scriptures largely take the place of the traditional symbolism. Second, the crosses that carry this sculpture develop a strongly architectural character and tend to be still loftier than the crosses of earlier centuries. Since these are the centuries of the fiercest Viking onslaughts it is possible there is a direct connection between this crisis and the change in the great Christian monuments. Are the size of the crosses, and resort to the sort of iconography with which all Christendom summoned its strength to resist danger, tokens of a supreme effort for survival? Were the elusive conjurations of Celtic symbolism too devious in face of the terrible reality of Viking axes? However it may have been, at this time it is hard to discern the thread of ancient tradition, except maybe in the continuing originality and superb aesthetic sense of those monuments which, it must not be forgotten, in their achievement are unlike anything produced outside the territories of the Gaels and the Cymri. That must be the justification for a diversion to sculptures which are far more closely linked with Romanesque art than with the broad theme of this book.

There appear to have been two or three centres in Ireland where schools of specially gifted sculptors flourished. One of them was associated with Monasterboice (Louth), now a quiet burial place with stately yews and a round tower conveniently near the Dundalk-Dublin road. The cross of Muiredach at Monasterboice is typical of this school, with shaft and cross-arms fully occupied by framed panels each portraying a Scriptural scene, the centre of the cross—on its west side—bearing the figure of Christ, but little larger than the figures on the shaft below. Apart from the wheel-cross itself, one has to look to such features as the hip-roofed shrine crowning the cross or the panels of knot-work on the sides to find anything not obviously derived from the Carolingians and the broad stream of European Christian art; and it is only by dwelling on the exquisite distribution and execution of the sculptures that one appreciates the debt owing to many centuries of artistry without which such a monument could never have been raised among the meadows and bogs of an island on the fringe of the Atlantic. There is an inscription, a plea for a prayer for Muiredach. The abbot Muiredach died in 923. Whatever the continental feeling of those representational sculptures, the detail reflects the community for which the cross was carved, for priests depicted carry Celtic croziers and the soldiers seizing Christ are plainly Vikings, sweeping moustaches, swords and all, which is no more than one would expect. Further to the south-west, at Clonmacnoise (Offaly), is another monument of the Monasterboice school, the Cross of the Scriptures. If somewhat

[1] Ibid., p. 128.

Ancient Monuments Commission for Scotland, is notable for a slender elegance not achieved by any other cross on either side of the Irish Sea. Further east, beyond the confines of Gaeldom, the Picts continued to develop their unique sculpture—although it should be recalled that the survival of the Picts as an independent nation ended in 844 with their union with the Scots. Class III Pictish stones carry no symbols, which may be significant of the passing of nationhood, and there is a growing use of imported devices. Mercian influence is strong. It is reflected in the iconography of such pieces as the Nigg stone (Easter Ross) and the sarcophagus in St Andrews Cathedral Museum. Dr Henderson has pointed out parallels between the sarcophagus and features of the Lichfield Gospels that suggest the Picts were strongly influenced by Hiberno-Saxon manuscripts at this time;[1] but they were never merely derivative, as can be seen in the spontaneity and acute observation shown in the hunting scenes on the sarcophagus and the Hilton of Cadboll slab in the National Museum of Antiquities. Those Pictish monuments are among the greatest examples of Dark-Age art in Europe. As to Man, Wales and Cornwall,

Fig. 45
HIRFYNNYDD SLAB, Wales
(Mon): 10th century A.D.
After photograph

there seems to have been much less exposure to such outside influences. Christian monuments in those areas at this period are much more unsophisticated. Even in Wales, which had continual intercourse with Ireland, religious symbols were incised on the surfaces of rough stones until perhaps as late as the ninth century, and it is all too obvious that Saxon pressure from the east kept the country in a state that allowed of little cultural

[1] Henderson, ibid., p. 150.

progress in the field of visual art. When low relief carving does appear somewhere in our present period it is evident that the sculptors had little traditional skill to call upon and were feeling their way painfully. The Maesmynis pillar-cross has much charm, but it is a tentative work. Its proportions are naive, the drawing is uncertain. Detail is confined to plait-work covering the entire surface. There is no attempt at iconography. The Hirfyn-nydd slab does have a figure, garbed in a tunic, with hands raised in exhortation or per-haps in a blessing. The head is an oval with features somewhat resembling traditional Celtic ones, although rudimentary might be a more accurate description. This has been referred to Merovingian inspiration. The cross-head in the churchyard at Llangan (Glamorgan), somewhat later in date, is more in the familiar tradition, with what looks like a huntsman on the shaft.

This chapter has traced what almost amounts to a submergence of Celtic tradition beneath a tide of foreign influences, Mediterranean, Byzantine, Germanic, with the independence of the Celtic peoples constantly threatened by the Vikings. The Irish and their neighbours survived the Vikings. Their art tradition was not extinguished. It even recovered a little of its strength, as will be seen in the next and final chapter, but its survival was fragmentary and precarious. It had not a little influence on Viking art, and

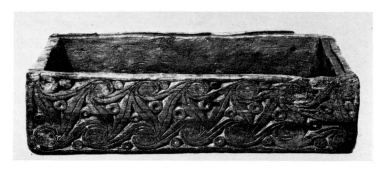

Plate 97 CARVED WOODEN BOX. Scotland—Birsay, Orkney: 8th–
10th centuries A.D. Length 29.2cm.
National Museum of Antiquities of Scotland, Edinburgh

one frequently recognises Celtic motifs on objects in the rich collections of the Scandina-vian museums. The recognition of traditional Celtic elements is not always easy. Naturally in the first place one looks for the persistance or re-emergence of obvious features of the La Tène style: for asymmetrical composition, for flowing linear motifs, even for aspects of the *tête coupée* in renderings of the human form. We have seen these things. The pages of the Book of Kells provide many examples of asymmetry and of linear patterns filling given compartments like swirls of coloured water, and more rarely similar passages appear in sculpture, e.g. on the south side of the cross of Muiredach, or even in Pictish territory as on the fragment of a cross from Tarbat in the National Museum of Anti-quities in Edinburgh. Sometimes a case of re-appearance is quite astonishing, as when a motif on the foot of the Schwarzenbach filigree gold bowl-mounting in Berlin is re-born

on a chip-carved wooden box from the Orkneys in the National Museum of Antiquities of Scotland. In the ninth and tenth centuries, however, there are fewer of those survivals than in the preceding centuries. One has to look through the work of art itself to the attitude of the artist, and here one enters the realm of speculation, often inconclusive. The hungry eclecticism of illuminator and sculptor could reflect the spirit of the ancient transalpine Celt, eagerly looking south, though eclecticism is not exclusive to the Celts. It could be the old Celt lurking behind the preoccupation with monsters and the delight in what I have called a 'Tolkien' world; yet this world is shared with other northern peoples. There can be small doubt that Celtic faith in symbolism played its part in driving

Plate 98 Fragment of STONE CROSS. Scotland—Tarbat, Easter Ross:
8th century A.D. Length 25cm.
National Museum of Antiquities of Scotland, Edinburgh

the Gael to erect high crosses in such numbers to rally the faithful against encroaching paganism, but of course the cross in other forms is common to all Christendom. It is clear, then, that by the end of the first millenium of our era the extraordinary, wayward and yet challenging style that had been at the centre of the Celtic contribution to European art wavered and wilted as the identity of the Celt himself merged with those of other peoples. Ardour, either martial or religious, had served to put life into the style, but without this it could not evolve; it was much more than decorative art. Its meaning is lost to us, except in so far as we may respond as we do to music we do not understand; but it was in fact a form of language, and with the coming of literacy the message and all the creative joy of proclaiming it could be perpetuated on the written page. Also, one senses twilight had begun to descend. The day that was gone already had become more important than a tomorrow which might well hold nothing to rally the spirit.

IX

Epilogue

In the eleventh and twelfth centuries the art of Ireland and the western seaboard of Britain has the appearance of being strongly Scandinavian, and certainly the relationship with Scandinavia was close. The Norsemen were no longer periodic raiders. They had long settled the Orkneys and Shetlands and the Hebrides. They had many bridgeheads in Ireland, among them the 'cities' of Dublin, Waterford and Limerick. Man had come totally under their control, and Wales had felt the weight of their power. The battle of Clontarf had ended the threat of Viking domination of Ireland, but the result did not drive the Norsemen from the area, and a period of something like integration followed during which the Norse built up trade from their seaport strongholds while the Irish fought among themselves about who should succeed Brian Boru as high king. The paramount threat had been barbarian paganism, and this was ending. The Norsemen were coming over to Christianity, and the monasteries were growing in strength and in wealth.

Unceasing pilgrimages and increased trade with the continent must have brought a swift and easy transition from the art style which we have seen develop in Ireland to the Romanesque, but for the belt of Scandinavian settlers. They were a vigorous stock. They cultivated a positive, rugged art style of their own, an uncompromisingly northern style, so much akin to the Irish tradition that it must have had a strong appeal for the Irish. The growing new strength of the church, now absorbing converts in large numbers from among the Norse settlers, fostered an art which drew heavily upon tradition, even refurbishing and remodelling old relics, yet reached out also to the new element in the community. The Viking danger ended, Norse art-forms suddenly became fashionable. It is perhaps not so unusual that things hated because associated with an enemy should become a cult when the danger passes. So, after a period of recovery in the first half of the eleventh century, something like a renaissance of religious art took place in which old forms of metalwork and sculpture and manuscripts were brought back, with a 'new look', a Norse look.

So strong is the Scandinavian feeling in the art of most of the western seaboard at this moment that it is sometimes said to belong to the Norse 'island style'.[1] Even individual Scandinavian styles, as will be noted presently, are unmistakably reflected in Irish art, as they are in English art. But relations are complex and the debt is not one-way.

[1] *Catalogue*, 'Norwegian Art Treasures' exhibition, Edinburgh, 1958, p. 24.

Shuttling of ideas back and forth between the various cultures of the era has woven webs that are nearly impossible to unpick. Total subjection to Scandinavian themes occurred nowhere in this area, although large parts of it were under Norse rule for as much as four centuries, and only the Isle of Man really seems to come near to it. In Man the sculptor whose name, Gaut, is inscribed on two monuments, is surely a Norseman, and he claimed that he was the author of all the carved stones on the island; yet he and his successors borrowed a great deal that was not Norse, including the form of the wheel-cross itself, probably ultimately derived from Pictish models, and in surface-carving distinct from the typical Irish patterns, a purely decorative treatment of plait-work and knots which does not appear to carry any of the symbolism or other subtleties that Irish work seldom seems to leave completely behind. There is a minimal amount of scriptural sculpture, limited to the scene of Daniel in the lions' den, and there is some animal sculpture, though on the whole Manx art tends to be rather alien to Celtic tradition. In Wales, Scandinavian art was much more fleeting in its impact. Anglian pressure from beyond the mountains made it more difficult for the native Celts to withdraw inland, more difficult than it was for the Celts of Dalriada, and this seems to have discouraged Norse settlements permanent enough to modify native styles, but there is some Norse feeling in the knot-work, as on the late eleventh-century cross of Abraham in the south transept of St David's cathedral, which has an Irish inscription. In Scotland, the effect of centuries of Viking depredations was to weaken the Celtic church in its long retreat from the Roman faith, isolating it, so that in the twelfth century the Canmore dynasty was able to overturn it, the surviving Culdee communities apart. However, those depredations were not followed by saturation with Norse monuments of the Sudreys, the southern Hebrides, as happened on Man, so closely linked with them. This domain of the Lochlannach, the Northmen, has of course produced a certain amount of Norse art in media other than stone, in metalwork for instance and in bone-carvings such as the celebrated Lewis chessmen. It was probably an area of relatively poor and peaceable peasant settlers, rather than warriors, if the dearth of weapon-finds is anything to go by, and without the monastic establishments to erect monuments. Such crosses as there are resemble those of Man, if they are crude in execution and rude in decoration beside the earlier monuments erected by the Celtic church. Finds which might be associated with a ruling class quite definitely reflect the Scandinavian taste which swept the west. A typical example is the hoard of brooches and other ornaments dating from the mid-tenth century found at Skaill in Orkney, and now in the National Museum of Antiquities. The brooches are penannular, with globular terminals engraved with a pattern which seems to be derived from the Jellinge style. With their stiletto-like pins, at one time proscribed in Ireland, as too-lengthy Spanish rapiers were proscribed in Elizabethan England, such brooches seem to symbolise the swaggering Celto-Norse chieftains of the kingdom of Somerled and his successors.

In Ireland, the debt to native tradition is manifest, as might be expected of a community which had fought back the invaders successfully. The strength of the church here

is decisive, not only for the patronage it made possible but for the discriminating eclecticism that it encouraged, providing again those conditions which in two previous eras had fostered Celtic art. It was not a great era like the earlier ones, yet the religious art of this time is rather magnificent. Reliquaries and croziers and crosses have a quality of splendour, and there are familiar continental elements, just enough of them, to render those pieces more comprehensible to our eyes than is some of the earlier work with its more subtle significance. There is even an architectural environment beginning to emerge. If Turlough O'Connor and his rivals were building their castles of timber, castles which have long disappeared, the monastic communities were raising structures of stone which are still with us, if usually ruinous. Glendalough among its trees, and Clonmacnoise, and Cormac's Chapel at Cashel, though innocent of transepts or even of pillars, have a simple dignity and character which is memorable, if unique only by reason of the traditional round tower cutting the skyline. The little sculpture they possess is limited to capital and chancel arch and the neighbourhood of doorways. Here one does find some relics of Celtic feeling in animal interlace, but of course there are also Norse monsters. There is a temptation to see *têtes coupées* in the projecting heads at Dysert O'Dea or Cashel or Clonmacnoise, especially when eyes are prominent and slit mouths are pursed, as above the portal at Dysert O'Dea, although those are probably deceptive as they are really Romanesque features which can be matched in churches of the period in France; the constant journeys of pilgrims can account for them. On the other hand the beast-heads which Dr Henry has placed in juxtaposition to the beast which holds the Cross of Cong in its jaws reflects the contemporary Irish trend. But it is, as one would expect, in the great crosses and the metalwork that the Irish heritage is recognisable, even in their very skill of execution and taste. The new Hiberno-Norse style perhaps owes rather more to ancient Celtic tradition than a first assessment might reveal. Certain motifs, for example the interlacing animals, had for centuries been shared by the arts of Celt and Teuton. Indeed the 'Jellinge' style of ornament, with its long, sinuous animals with hind legs replaced by spirals or by leaves, that had influenced Irish art in the ninth century, is,

Fig. 46
JELLINGE STYLE, Harald Gormsson's monument
Kendrick, *Late Saxon and Viking Art*

160

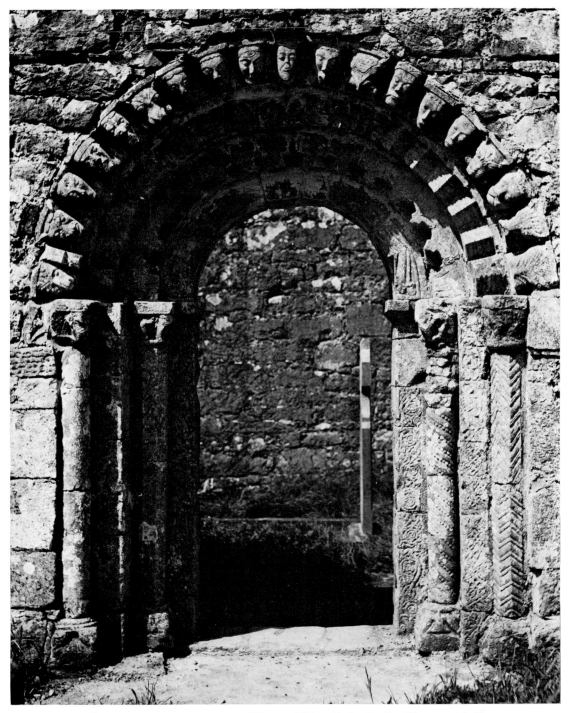

Plate 99 PORTAL, monastery of Dysert O'Dea. Ireland—Co. Clare: 2nd half
12th century A.D.

Fig. 47
RINGERIKE STYLE, Bury
St Edmund's psalter
Kendrick, *Late Saxon and
Viking Art*

in the words of T. D. Kendrick,[1] 'a mannered Scandinavian version of the equivalent Irish or Hiberno-Saxon ornaments', such ornaments as the detail of the Tara brooch.

In the later eleventh century the Scandinavian styles followed in Ireland were, first and briefly, the Ringerike, then more extensively the Urnes. The Ringerike style, in which scrolling tendrils break into little leaf-ends that seem to owe something to the

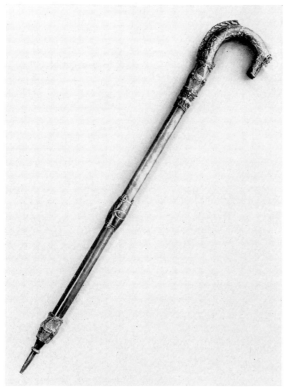

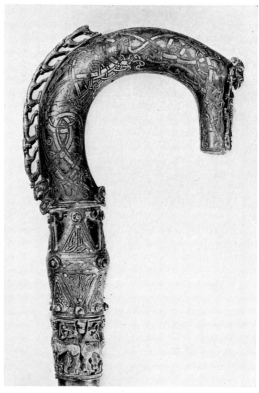

Plate 100 THE CLONMACNOISE CROZIER, bronze
inset with silver and niello. Ireland:
end of 11th century A.D. Length 96cm.
National Museum of Ireland, Dublin

Plate 101 THE CLONMACNOISE CROZIER:
crook in detail

[1] *Late Saxon and Viking Art*, London, 1949, p. 88.

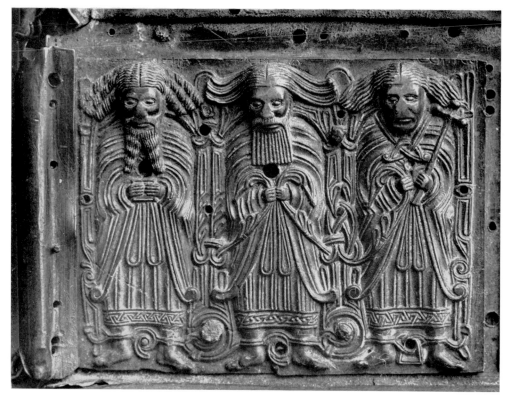

Plate 108 PANEL, bronze, from the Breac Maodhog. Ireland—Co. Cavan:
early 12th century A.D. Length 5.1 cm.
National Museum of Ireland, Dublin

of the World.[1] There is a rather earlier transitional variety of cross of which perhaps the best example is in the churchyard at Drumcliff (Sligo), within a few yards of the grave of Yeats. Here we have a wheel-cross with some crude and clumsy figures balanced by decorative panels of great precision and beauty, some traditional, some carved with a Scandinavian Urnes pattern.

The Anglo-Norman invasion of Ireland in the twelfth century overturned traditional and current art forms in a way never achieved by Scandinavian pressure. It is not that the Normans conquered Ireland. In course of time they were absorbed and became an element in the country, as happened elsewhere. They did, however, open the door wider than ever before to continental culture, and the church became an extension of the orthodox church in all its fabric and furniture, so that Romanesque art, which hitherto had edged in little by little, now began to dominate all. As late as the middle ages (1350), one may see in the silver case of the 'Domnach Airgid' (National Museum, Dublin), made to contain St Patrick's Gospel, some faint vestiges of traditional feeling in some of the tiny trailing scrolls and knots and the plait-work on the top; at the same time this piece must

[1] Ibid., p. 139.

167

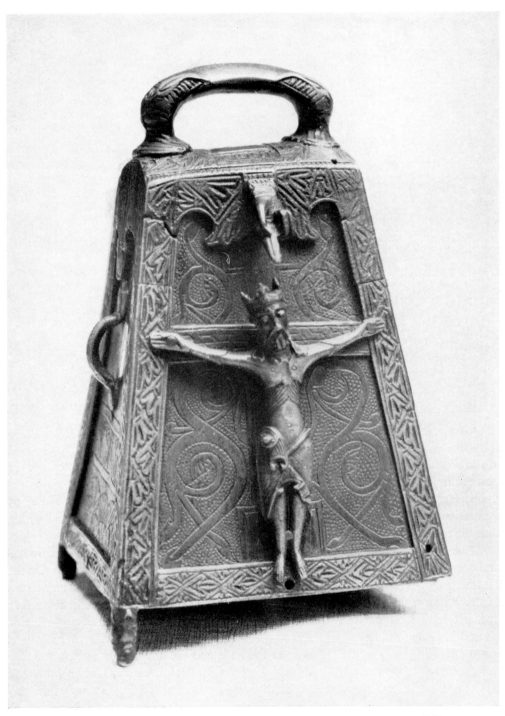

Plate 109 BRONZE BELL-SHRINE. Scotland—Kilmichael-Glassary, Argyllshire:
late 12th century A.D. Height 15.2cm.
National Museum of Antiquities of Scotland, Edinburgh

be indicative of the way Irish ecclesiastical metalwork was going. Dr Henry has of course pointed out that Romanesque art was itself open to the influence of Irish art through the medium of the manuscripts, and she maintains that the debt to Ireland could extend beyond the mere borrowing of patterns to certain aspects of the very basis of construction.[1] There is no doubt, however, that a transformation began to take place in the twelfth century and that it grows more and more difficult to discern the older features or feeling in the major works which have survived. For many centuries Ireland had been the last refuge of Celtic tradition, and culturally speaking now this refuge had fallen— even literature, as the de Paors point out, entered an era of compilation, sterile in thought. Only over in Scotland, particularly in the untamed region around the ancient Dalriada familiar in medieval history as the Lordship of the Isles, did the tradition precariously survive.

The Lordship of the Isles is a romantic and evocative term and all too easily conjures up visions of things that have no foundation in fact. For a start, it should be remembered that the independence and much of the character of this unruly area known until the fourteenth century simply as the Sudreys were the result not of Celtic obduracy but of Norse domination.[2] But when we have allowed for this and for continental influences which reached here as everywhere else in the British islands, there is in many works both of stone sculpture and of metalwork which have come out of the western Highlands and islands a quality, full of grace and often even of sophistication, which points to the Dalriad past and to the Irish culture that lay behind it. David I in the twelfth century strove to destroy the Celtic church, doing all he could to incorporate the *Keledei*, the Culdees, as canons regular; yet some of those devout hermits survived until the fourteenth century, and Celtic forms of worship must have survived at least as long. There are two twelfth-century bell-shrines in Scotland (National Museum of Antiquities), those of Kilmichael-Glassary and Guthrie. If the most prominent feature of the first is a figure of Christ modelled in the Romanesque manner, the rather crudely-drawn ground pattern of foliate scrolls suggests some vague familiarity with Hiberno-Saxon work, and indeed the concept of the bell-shrine is in itself significant. The bronze crook of the Quigrich or crozier of St Fillan in the same museum now lacks its decorative panels, but it seems to belong to the eleventh century and may well have originated in Ireland. Its silver-gilt case, on the other hand, is as late as the last part of the fourteenth century. Its ornament is in the style of the period, except that some of the filigree plaques, those of better quality, may have been transferred from the crozier itself, the rest being copied by a hand much less skilled. The main interest of the Quigrich in discussing the survival of Celtic traditions lies less in itself than in the implication of lingering feeling for the outer forms at least of the early church. We know from the record of an inquest on the 'Coygerach' which took place in April 1428, that the heritable office of custodian of such relics was still in being, and this in itself is a perpetuation of the ancient Irish 'keeper' system which gave the responsibility

[1] George Henderson, *The Norse Influence on Celtic Scotland*, Glasgow, 1910, *passim*.
[2] Ibid., p. 205.

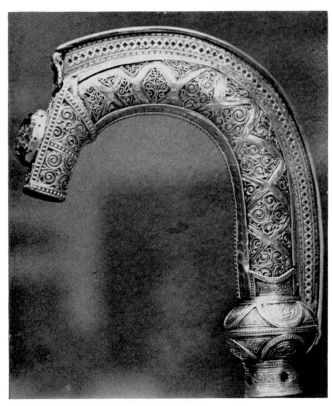

Plate 110 CASE OF THE QUIGRICH OR CROZIER OF
ST FILLAN, silver-gilt. Scotland:
late 14th century A.D. Height (crook) 23cm.
National Museum of Antiquities of Scotland,
Edinburgh

of the safe-keeping of the shrine of St Patrick's Bell, for instance, to the family of the Mulhollands. A secular relic of the same period is the cup preserved at Dunvegan Castle in Skye. It has long association with the Macleod family, but is of Irish origin. The Latin inscription on the outside of the rim refers to a John Macguire, '*Principis de Fermanac*', and states that the cup was made in 1493. Macguire, who is referred to in the *Annals of the Four Masters*, became chief of his clan in 1484. Macleod tradition has it that the rim was attached in the year inscribed on it; however, the other silver mounts of the original wooden mether seem to me to have features resembling details of the 'Domnach Airgid' in Dublin, notably the six-pointed stars and the little filigree knots.

The western seaboard of Scotland makes a contribution to the art of the middle ages in a wide range of sculptured stones of rare beauty. They are in some ways parallel to, yet quite outside, the main European stream of the thirteenth, fourteenth and fifteenth centuries. To encounter one of them half-buried among nettles or bracken in a country-side of superb natural amenity but almost as innocent of the marks of civilisation as any

JACOBSTHAL, PAUL, *Early Celtic Art*, London, 2 Vols., new ed., 1970

KENDRICK, T. D., *Anglo-Saxon Art to A.D. 900*, London, 1938

KENDRICK, T. D., *Late Saxon and Viking Art*, London, 1949

KERMODE, P. M. C., *Manx Crosses*, London, 1907

LEEDS, E. T., *Celtic Ornament*, Oxford, 1923

LETHBRIDGE, T. C., *The Painted Men*, London, 1954

LOOMIS, R. S. (ed.), *Arthurian Literature in the Middle Ages*, Oxford, 1949

MACDONALD, GEORGE, *Catalogue of Greek Coins in the Hunterian Collection*, Vol. III, Glasgow, 1905

MAHR, ADOLF, *Ancient Irish Handicraft*, Limerick, 1939

MEGAW, J. V. S., *Art of the European Iron Age*, Bath, 1970

MILLER, E. G., *The Lindisfarne Gospels*, London, 1923

MORTON, FRIEDRICH, *Hallstatt und die Hallstattzeit*, Hallstatt, 1955

NASH-WILLIAMS, V. E., *The Early Christian Monuments of Wales*, Cardiff, 1950

O'DELL, A. C. and CAIN, A., *The St Ninian's Isle Silver Hoard*, Aberdeen, 1960

PIGGOTT, STUART, *The Druids*, London, 1968

PIGGOTT, STUART (ed.), *Early Celtic Art*, Catalogue of Exhibition, Edinburgh and London, 1970

PIGGOTT, STUART, and DANIEL, GLYN, *A Picture Book of Ancient British Art*, Cambridge, 1951

POBÉ, MARCEL, and ROUBIER, JEAN, *The Art of Roman Gaul*, London, 1961

PORTER, A. KINGSLEY, *The Crosses and Culture of Ireland*, Yale, 1931

POWELL, T. G. E., *The Celts*, London, 1958

POWELL, T. G. E., *Prehistoric Art*, London, 1966

RICE, TAMARA TALBOT, *The Scythians*, London, 1957

ROSS, ANNE, *Pagan Celtic Britain*, London, 1967

ROSS, ANNE, *Everyday Life of the Pagan Celts*, London, 1970

SANDARS, N. K., *Prehistoric Art in Europe*, London, 1968

SAXL, F., and WITTKOWER, R., *British Art and the Mediterranean*, Oxford, 1948

SIMPSON, DOUGLAS, *The Celtic Church in Scotland*, Aberdeen, 1935

STEVENSON, R. B. K., *Kolloquium über Frühmittelalterliche Skulptur* 1970 (University of Heidelberg), Mainz (to be published)

STRZYGOWSKI, JOSEF, *Origin of Christian Church Art*, Oxford, 1923

STRZYGOWSKI, JOSEF, *Early Church Art in Northern Europe*, London, 1928

STUART, JOHN, *Sculptured Stones of Scotland*, 2 Vols., Aberdeen, 1856, and Edinburgh, 1867

SULLIVAN, EDWARD, *The Book of Kells*, London, 1914

WAINWRIGHT, FREDERICK T. (ed.), *The Problem of the Picts*, Edinburgh, 1955

Index